SNIFFING THE REGION

Being tagged a regional artist doesn't hurt much. Of course the term may imply accomplishment that is worthy only if assessed locally; but being regional may just mean you use references that seem remote and special because the public is elsewhere and hence limited by immersion in a region distinct from the artist's. So—artists from another region are distinct—"provincial," even—but without adverse reflection on their accomplishment.

And in a sense any artist has to be regional. Doing art takes a kind of sniffing along, being steadfastly available to the signals emerging from encounters with the material of the art—the touches, sounds, balancings, phrasings—and the sequential and accumulating results of such encounters.

To look up from the sniffing, in order to find a critic's approval or a public's taste, is to forsake the trail. And that trail is one-person wide, terribly local and provincial: art is absolutely individual in a non-forensic but utterly unyielding way.

Anyone actually doing art needs to maintain this knack for responding to the immediate, the region; for that's where art is. Its distinction from the academic, the administrative, the mechanical, lies in its leaning away from the past and into the future that is emerging right at the time from the myriadly active, local relations of the artist. Others—administrators, professors, mechanics, or whoever—can of course also be responsive to where they find themselves:—artists have to be. That's the ground for their art, the place where they live.

William Stafford
Lake Oswego, Oregon
from *Brother Wind*, Honeybrook Press, 1986

Alan Gussow

John Driscoll

Introduction

and Statements by
Fifty-three Artists

The Artist

as Native:
Reinventing Regionalism

POMEGRANATE ARTBOOKS
SAN FRANCISCO, CALIFORNIA

A CHAMELEON BOOK

Complete © 1993 Chameleon Books, Inc.
Text © Alan Gussow

Published by Pomegranate Artbooks
Box 6099, Rohnert Park, California 94927

Produced by Chameleon Books, Inc.
211 West 20th Street, New York, New York 10011

Creative director: Arnold Skolnick
Editorial assistants: Lynn Schumann, Nancy Crompton
Composition: Larry Lorber, Ultracomp
Printer: Oceanic Graphic Printing, Hong Kong

Library of Congress Cataloging-in-Publication Data

Gussow, Alan, 1931-
 The artist as native : reinventing regionalism / Alan Gussow.
 p. cm.
 "A Chameleon book."
 Exhibition catalog.
 ISBN 1-56640-596-3. − ISBN 1-56640-675-7 (pbk.)
 1. Regionalism in art−United States−Exhibitions. 2. Painting,
American−Exhibitions. 3. Painting, Modern−20th century−United
States−Exhibitions. I. Title.
ND212.G87 1993 93-24779
759.13'0904507473−dc20 CIP

To Adam and Seth, and to Our Garden in Congers

Contents

Acknowledgements

Among the several meanings of the word "acknowledgement" are two which are pertinent here. The first has to do with the act of admitting or owning to something. The second is the more usual use of the word in connection with a publishing effort—an expression of appreciation or thanks. As to the first meaning, a confession is in order. The artists whose work and words are included in this book would, if asked, never have described themselves as regionalists. Nor for that matter would they have thought of themselves as native. Both "native" and "regionalist" have, in recent years, taken on somewhat negative associations. The phrase "to go native" implies no deep relationship to a time or place, but the donning of a presently fashionable primitivism. To be described as a regionalist is to risk being considered provincial.

The assignment of the artists in this book to these categories is my doing, not theirs, and I accept full responsibility for that act. I believe strongly that we must all become native to our places, that we must all develop a regional self-definition so that we both nurture and are nurtured by our surroundings. Because these artists have all done that, I consider the categories to which I have assigned them both complimentary and necessary.

As for expressions of thanks, my first thoughts go to the artists themselves, for their willingness to answer my questions, and even more, for their generosity in directing me to still other painters who belong in this company. Without their help, I could never have hoped to locate fifty-three artists from all parts of the country who fit the frame of the book and show I envisioned.

During the two years I spent gathering the material for this book, one person was a faithfully reassuring force. If John Driscoll, Director of the Babcock Galleries, wondered from time to time what he had committed himself to, he kept his doubts to himself. He has been a constant touchstone—critical, supportive and abiding. Kathryn Mannix, also of the Babcock Galleries, cheerfully and buoyantly undertook the drudge work associated with this publication, gathering slides, releases, check lists, whatever. Adding to the support of "Team Babcock" has been Jeanne Baker, whose interest and encouragment have been constant.

Finally, a few public words of praise for my wife, Joan. A book, any book, takes time to produce. Moods vary, needs change, the highs of creativity yield to days of great uncertainty. Joan was always there, steady, consistent, sustaining, generous with her time, precise with her editing, never merely idle with praise, a true partner.

Alan Gussow
Congers, New York
December, 1992

List of Artists

The Art of Regional Soaring

AN INTRODUCTION

THE WONDER OF A NEW EXHIBITION is that it can make people—artists and viewers—recognize thoughts and feelings they hardly ever noticed before. Some twenty years ago, Alan Gussow organized the exhibition "A Sense of Place." Doing so, he created an awareness of artists, sites and affinities so cogent that people still speak—these many years later—of the exhibition and its accompanying book as though it were still going on, still shown and viewed and discussed in cities across the country. The thoughts and feelings people experienced in response to "A Sense of Place" stimulated updrafts across the country, carrying artists and viewers like eagles, carving the wind, and looking down on earth high enough so that order confounds the chaos.

When Alan first approached me with his idea for a new exhibition, to explore how the impact of "A Sense of Place" had matured or withered through two decades, it was exciting. As Director of one of America's oldest art galleries, I thought Alan's idea might best be served by the sponsorship of a public institution. Yet, it also appeared that the private sector might encourage such a project—for ultimately, public or private, we all strive, on good days, to discover order in chaos and to soar on the power of new ideas. I encouraged Alan to go ahead but to think small; to devise a neat little summer show of, say, twenty or so artists, and to think about a modest brochure. Yet, from the very beginning of our discussion about *The Artist as Native*, the quiet yet authoritative mischief in Alan's lively eyes betrayed a grander scheme. While he calmly and reassuringly acknowledged that we must think small, we both somehow knew that Alan was rightly thinking big. Alan's artistry touches and celebrates all that he does, and it was clear that he had in mind some serious soaring.

Thus, Alan willed *The Artist as Native* into being and, in so doing, discovered artists all over the country reinventing regionalism. To some, the idea of regionalism can have tedious connotations. What Alan has found, however, is that regionalism today is a question of articulating thoughts and feelings that swiftly alert a vital intelligence to the universal in the local. There is perhaps nowhere on earth more regionalist in its art than New York City—or, more specifically, Soho. Yet, we learn from this exhibition and the individuals who are participating that whether one works in Soho or Honolulu, the artistic life of a generation of visual artists is firmly grounded in specific locales while simultaneously embracing major jet streams. The potential pretense of such an idea is thoroughly eroded by the evidence of soaring at hand in this exhibition and in the written statements each artist offers in the following pages.

The Artist as Native celebrates the artistic visions, the cultural diversity, philosophical commitments, innovative thinking and daily hard work that these artists, and others across the country,

assert in the creation of their imagery. Such elements offer the opportunity for artists and viewers alike to acquaint themselves with durable new ideas and feelings: with the previously little noticed. For some, we can already sense flights of fancy, wings dexterously feeling the winds, selecting opportunities. Let the soaring begin!

John Driscoll
Director, Babcock Galleries, New York City
March, 1993

THE ARTIST AS NATIVE:
REINVENTING REGIONALISM

THIS IS A BOOK ABOUT ARTISTS and the images they paint. It is also about a new kind of regionalism, a way of looking at and responding to the land vastly different from the down-home sentimentalism of the regional school of painting which dominated American art during the Depression days of the 1930s.

The nation has changed greatly since the thirties. We have moved off the land into cities and suburbs. The environment has been stressed. We have grayed our skies and fouled our streams and rivers. There are more of us living in this country and we live closer to each other now. We try to place a value on remnants from an earlier time, on old houses, on open spaces, on our majestic rivers and our freshening streams. We seek, with much difficulty, to become a true nation by finding ways to incorporate new pilgrims. We struggle to reverse environmental degradation, to restrain the loggers and the developers. Some artists try to see, understand and ultimately make visible the ecological interconnections which bind us to each other and to the communities and neighborhoods we inhabit.

This new regionalism, what Peter Berg calls bioregionalism, "refers both to geographical terrain and [to] a terrain of consciousness—to a place and the ideas that have developed about how to live in that place." Berg has come up with a new word to describe the process of living-in-place in an area that has been disrupted and injured through past exploitation. His word is "reinhabitation," and he writes, "it involves becoming native to a place through becoming aware of the particular ecological relationships that operate within and around it. It means understanding activities," he continues, "and evolving social behavior that will enrich the life of that place."

Today there are artists in every part of our nation who have become native to their place. They see the world around them with unblinking clarity, they make vivid their connections to soil, to structures, and to the lives, human and otherwise, which inhabit their places. "I like the song of the garbage trucks at five in the morning," writes painter Catherine Redmond from Manhattan, "but I also like the sound of the apricot-brown mourning dove on the kitchen ledge. We are all in this together. I prefer the world as I find it, the world which is not dressed up and on its best behavior, but as it is on a Wednesday morning going about its business and unaware of itself. Here there is extraordinary beauty." It is not simply acceptance that characterizes Catherine Redmond's relationship to the city, but rather her attachment, intimacy and familiarity with the place where she lives.

The artists whose work is reproduced in this book have two things in common. They each make images prompted by experiences in a home location. That is to say, they all live in places that shape what they see, touch and hear. Painter Marcia Clark says, "My knowledge of the earth is

experiential. I don't know how much it has to do with expressing ecological fact—perhaps more the living of it."

The second quality common to these painters is that none of them burden their paintings with the need to carry a message. That they despair about the changing environment there is no question. That those who depict the surrounding landscape must adjust to change there can be no argument. Artist Sheridan Lord, whose paintings are inspired by the potato fields of Sagaponack, Long Island, writes, "I paint outside in the field much less now and have not worked off our own property in the past seven years. I paint more closed views. Many, if not most, of the open panoramas have disappeared....I wonder if I can be the sort of painter who will be able to use the skills and knowledge so slowly developed over twenty years to mine further, perhaps differently, a landscape I once loved."

The only weapon artists possess to express rage against environmental destruction is their ability to make visible what they experience and what they value. It is doubtful that the painters gathered here would describe themselves as bioregionalists. Yet, by sensing interconnections between sky and soil, between the buildings and the light, between things that grow and structures that decay, by being alert to changes, by possessing a quick and piercing eye, these artists are helping to focus our consciousness on the degradation of the environment. These artists sense the resonance among living organisms. Their paintings are a kind of mapping of an experiential terrain. Reflecting on this struggle, artist David Utiger, who lives in a remote part of Vermont, writes, "I like to think of my art as a humble attempt to fight back against an increasingly mass-marketed, mass-produced and banal world. My way of fighting back is to create precious, personal and sensitive one-of-a-kind works of art."

The cultural experiences of these artists vary greatly. Peter Jemison writes from upstate New York, "I am a Seneca...I believe the work I do is the product of where I live and all the forces that influence my life." Jemison's declaration would also apply to Benito Huerta, who states, "I am a native to Texas. My work gives expression to my being not only a native in place but also culturally as well. My work," Huerta continues, "has dealt with many issues that reflect who I am, such as being a Chicano (a hybrid of two cultures), being brought up a Catholic (which I am not anymore, but its influences are still reverberating), being a Texan, and also my relation to the world."

From her studio just outside of Philadelphia, Celia Reisman writes, "I feel I am truly a native of the suburbs....Not only am I familiar with the physical manifestations of these older neighborhoods, but there is an emotional component that I am connected to as well....There is decay and deterioration of the older structures that reflects the fears, hopes and dreams of the people inside. All of this creates a mystery that I can use in my work....It is the suburban settings, the congestion and compactness of these altered landscapes, where I feel most able to imagine and transform the physical environment into another world." From the suburbs to a wild California coast, the words of painter Judy Molyneux describe a different world: "I look for places with bone and power, places where the convulsions of the earthquakes show through—mighty fists and windswept valleys that rush down to the sea."

These artists do not claim they experience the world more deeply than others. They are not equipped with special antennae which permit them to feel what others do not feel. What these artists do possess, however, and what all artists—poets, dancers and musicians—possess, is the ability to take experience and make it concrete so that feelings may be shared. In their separate and individual ways they are drawn to different locations and to different phenomena. Some seek wasted urban places. Others yearn for rain and oceans and what painter Dana Roberts describes as "the slow drip of familiarity." Still others are lured to the panoramic or the eventful; some celebrate the seductive blooms of flowers while others find beauty in the shadowed overpasses of interstate highways. Always it is the sudden revelation in a familiar place, the moment of memorable clarity when what has been seen often is seen as if for the first time.

The paintings gathered in this volume do not constitute a school. Most of the artists are unknown to each other and to the nation as a whole. Yet, in their own regions they are often revered. The truths they discover about their own places are likely to bring their work to an ever widening, appreciative audience. They come from all parts of the nation, from Miami to Oakland, California, from south Georgia and Corpus Christi to the southern tip of Manhattan, from the northernmost coastal town in Maine to the Hawaiian Islands, from New Mexico to Kentucky to Minnesota, and to the San Juan Islands of Washington State, among other places.

Poet Adrienne Rich once wrote (in *The Tourist and the Town*), "To work and suffer is to be at home. All else is scenery." We have not searched for paintings of scenery. The artworks reproduced here have all been prompted by the intimate interaction of an artist with a home location. In a world set free by the nonmaterial flow of information, it is important, we believe, to remind people that they do indeed live somewhere, that places, those parts of the world we claim with our feelings, have value. Part of the implicit message of this book is that, even as we depend on places, these places depend upon us. This volume is about mutual influences and symbiotic relationships. We seek to elevate the vernacular, to give meaning to the common, to locate and share paintings which, at least in part, emerge out of local knowing.

Alan Gussow
Congers, New York
December, 1992

My work arises out of the northern New England landscape. It is where I choose to live, for the primary reason that it is the only place I feel comfortable. Some people find rural places very threatening, especially a northern area like this which often has an inhospitable climate....Another reason why my art is connected to the area I live is that I have a hereditary attachment to it. It is a feeling that is hard to avoid when your relatives have lived in the same town for about two hundred years. Because of our increasingly transient society most Americans don't have any or have forgotten their roots.

This is a part of the world that has the four distinct seasons. In fact, the more north you travel, the more distinct the seasons become. The Quebec-Vermont border is exactly 45 degrees N, precisely half way between the equator and the North Pole. The amount of daylight and the angle of the sun change as the year progresses. I like to depict scenes that reflect the kind of light at that time of year. I like to think of my art as a humble attempt to fight back against an increasingly mass-marketed, mass-produced and banal world. My way of fighting back is to create precious, personal and sensitive one-of-a-kind works of art. The goal of my painting, *City on the Hill*, was to show how a small community of people working and living together in harmony with the land can flourish, how agriculture practiced wisely can be abundant and sustainable....In this painting I try to depict a New Jerusalem in a New England setting, with Lake Champlain receding into the distance.

David F. Utiger
Peru, Vermont

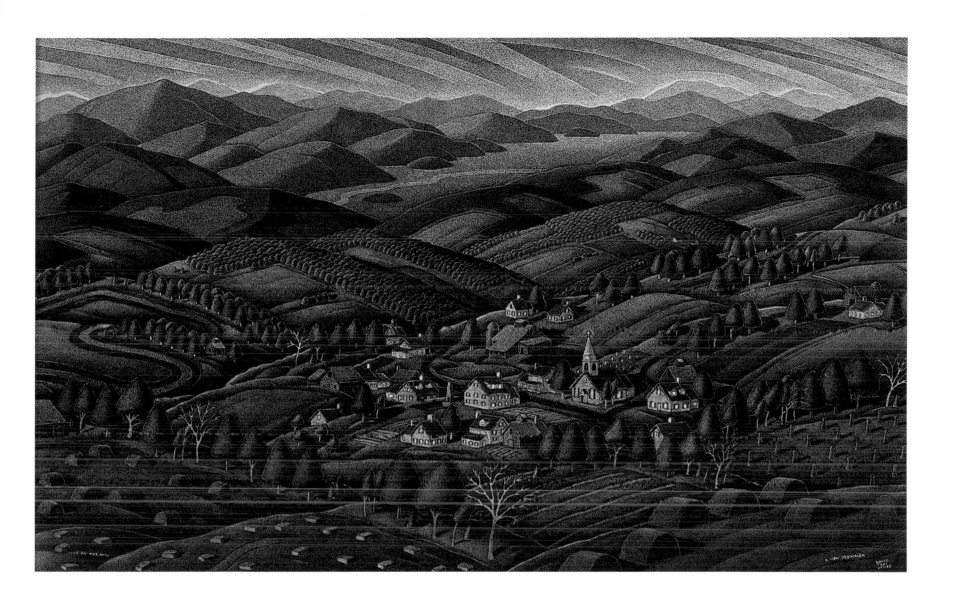

CITY ON THE HILL, Mixed media, 16 x 27 inches

I was born in Boston and spent much of my youth in Canada from Montreal to Prince Edward Island. The middle of Maine along the coast is the exact center of the world I have explored. From Freeport to Stonington is the heart of my world. I have lived in the same house for almost thirty years. That's about as native as you can get. My work is very much about this area and it is even more about my own evolution in trying to understand the mysterious and sublime wonders of this small part of our precious world.

Ultimately, I probably live in Maine because the seasons are dramatic and free-wheeling. As one completely intrigued with the growing cycles and the qualities of light and air, I can often tell which week of the year it is. As a life-long sailor you can get pretty close with just the variations in the wind. Northeasters in November, March and July all have distinctly different qualities, as do southerlies in December, April and August. Or you can always cheat and look at the heavens. Visually, the winter in Maine is simply incredible.

I really don't consciously look for "places" that promise to be good subjects for paintings. Rather, I intuitively try to respond to nature as it presents fascinating combinations of land, sky, water, and light. Most often, the particular places that I paint are the ones that seem very pure and in tune with the natural process. A place that might be wonderful in late February with snow around and a broken sky, might be a complete dud in the middle of July.

I have a vegetable garden and work on our house and five acres of land. I have sailed most of my life and, fifteen years ago, designed and built a thirty-five foot cold-molded sailboat. My family and I sail and cruise the coast of Maine from Casco Bay to Winter Harbor. I even spent three and one-half years as a full-time lobster fisherman. I love getting all geared up in the heart of the winter and going out, just exploring the amazing visual phenomenon of this place.

Thomas Crotty
Freeport, Maine

BUNGANUC ROAD, 1993, Oil on canvas, 24 x 40 inches
Photograph: Jay York

During the summer of 1991, Carol Field and I began a collaborative project that took as its subject the waterway that connects us, the Hudson River. We jointly and individually visited numerous sites throughout the watershed and explored numerous drawing ideas, including several collaborative structures. Carol introduced a form where a freehand map of the site would be folded into a number of sections. Then, each of us would draw into the folded segments our observations made at the site. *From Spring to Reservoir* is an example of this form. One day we visited Croton Dam and Reservoir in Westchester County, New York, which is part of New York City's water supply. Carol sketched the map and two views of the dam. Then it started to rain and we left the site before I could do my part. I added the color and my two sections later. One is a view of a concrete spring box below my house and the other is a large spring deep in the woods on the side of a nearby mountain. Although they are a hundred and twenty-five miles apart, the three sites share a similar purpose as sources for clean, safe drinking water. Our project came to be called "Drawing from the Hudson River Watershed" and was greatly assisted by a grant from the Vermont Community Foundation.

Bill Botzow
Pownal, Vermont, and

Carol Field
New Paltz, New York

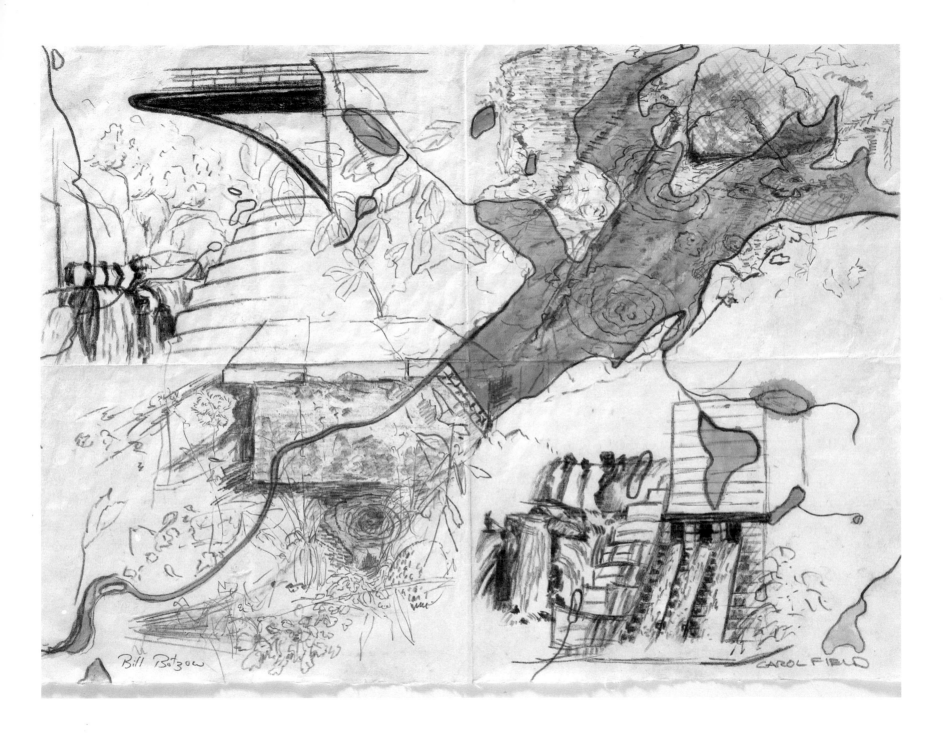

FROM SPRING TO RESERVOIR, 1991–92, Watercolor, ink and pencil on paper, 19 x 25 inches

19

All places looked too picturesque month after month, and I was starving to paint. Finally, one June morning at dawn, I tore out impulsively to snip some peonies at a neighbor's. Walking back, I distrusted painting them, but I was intrigued by each in a different stage of bloom or decay—some transparent, some iridescent and some crusty. Once in my yard, I held a mini-landscape in my hand; a simple glass jar of water, of unarranged shapes, textures and colors and reflections—then I set it on a small black tin tray atop a wobbly little metal table from the Rite Aid.

Don't rearrange fate. No bouquets in vases. No foreground, middleground, or background, and no cubism. But other nears and fars, turns and twists and contrasts, were there. The transitory and ever-changing light were all, when suddenly an impossible force of wind shattered the "bouquet" and set me on a new course. And I couldn't paint in the house. I needed to hear, see and smell the sea, dig the easel into the grass and feel the freedom of getting out in the air and in my yard. The peonies had to be painted, and I found my way in the wind over and over again.

Four years ago I moved into this house. Here once stood an old shack where I stayed for several summers of landscape painting. Now, living with all the seasonal transitions and surviving the wild storms and blizzards, power outages and leaks, I look to the practical and real much more. I watch for the dawn and dusk, the high and low tides and shifts in water reflections by the minute, and for the cycle of the moon, the fog, the sea smoke; I pray for the brave fishermen and their boats. Constantly I wish for another lifetime to work with these deep forces. I am possessed by this wish.

In late October, the big, dark clouds come back and a few bright spots of orange or red foliage sing out against the naked limbs, crumbled up leaves, long, dark shadows and evergreens. Almost always I am outside—painting in all my layers or else keeping up with endless yard chores.

Early March in the studio I am usually wrestling with another large canvas that includes a window view. Extra minutes of brighter light seem to pour in daily, and I grow restless anticipating spring blossoms while the cold wind encircles the house.

These are threshold times for me.

First, truckloads of dirt and gravel fill were hauled in, and then followed the grading of the land. I planted grass and now mow it. I turned an old outhouse into a shed, but now I need a serious shed. New here are fifty-two shrubs and trees I've planted plus countless perennial flowers. In the spring, I prepare a vegetable garden and plant annual flower seeds and seedlings. I like the physical work but especially enjoy long, long walks and gazing off to where the sea meets the sky.

Sharon Yates
Lubec, Maine

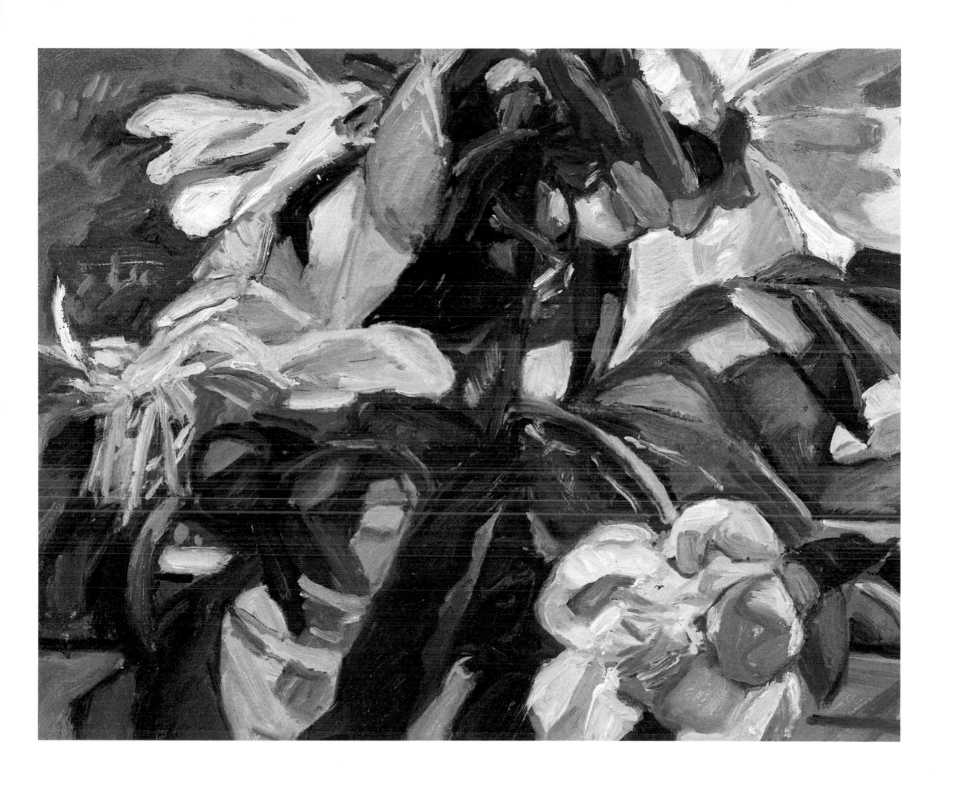

PEONIES NO. 6, 1992, Oil on canvas, 8⅝ x10⅝ inches
Photograph: Al Mather

My work is often generated out of a distant memory of a physical setting that becomes a metaphor for a personal truth. As a child I had the good fortune of woods, open fields and farmland in which to play. When I was nine my father, who was a Presbyterian minister, took a pastorate in Huntington, Long Island, on the north shore. It was in the mid-nineteen forties, and Huntington was still considered a village. It was a quiet place of natural beauty, and my imaginative life was very much centered on continuing play in the woods as well as the added blessing of water. When I was eighteen the family made another move to Denver, Colorado, and I finished my college education in the Northwest. It was in the West that I first encountered mountains on a grand scale. When I returned to Boston for graduate study many hours were spent in Lanesville, looking again out to the sea.

Although the experience of nature as manifest in woods, water and mountains was central to my childhood, I was not conscious of being drawn back to it as a source for my work until we returned to the Northwest in 1963. For ten years we lived on a farm that bridged the Little Spokane River. It was from daily observing the silver light, space and temperature transforming a pasture, grove of trees or the run of water that I found myself preoccupied with the spirit and grandeur of the place. Anticipating the time when we would have to leave this remarkable setting, it seemed a given that we should try to repeat the experience elsewhere. We searched for property and finally located forty acres, fifty miles north of Spokane in the mountains. We built by hand a studio/house and for the last twenty years have returned every summer to witness the beauty of a landscape that we love, something like Wallace Stegner's return from the West Coast to summer in Vermont. The paintings and drawings, then, are built out of an extended exposure to what is seen and felt, trying to understand what lies behind the appearance of the natural form. I work totally from memory, with each piece developing on its own. The surprise of the finished piece can recall a beach on Long Island Sound, an island in the San Juans or a well-traveled road in the Northwest. At another level it is clear that I am trying to hold/reflect the lost moment, break through the fence of time and reclaim what was given to me as a child on a first-time basis. At its best the final statement conveys a distilled sensation of time.

Ben Frank Moss
Lyme, New Hampshire

MEMORY OF HFM, NO. 2, 1992
Oil on canvas, 34 x 27 inches
Photograph: John Sheldon
23

I regret that I cannot answer your questions. Maine is being ruined by tourism. My beloved Cranberry Island habitat is inexorably changing —its wildness destroyed. I am too distraught to write about it.

Emily Nelligan
Winsted, Connecticut, and Cranberry Island, Maine

CRANBERRY ISLAND, THE POOL, 1990, Charcoal on paper, 7½ x 10½ inches

I have difficulty of late with themes. Native...place...these have become increasingly alien. My value system is quaintly archaic. My relationships, both people and environment, have little nutriment. The paintings are fueled more from an inner source than from an external "place." My long residency in this location, I confess, results more from a lack of other options than from a conscious choice.

Richard Bogart
Easton, Connecticut

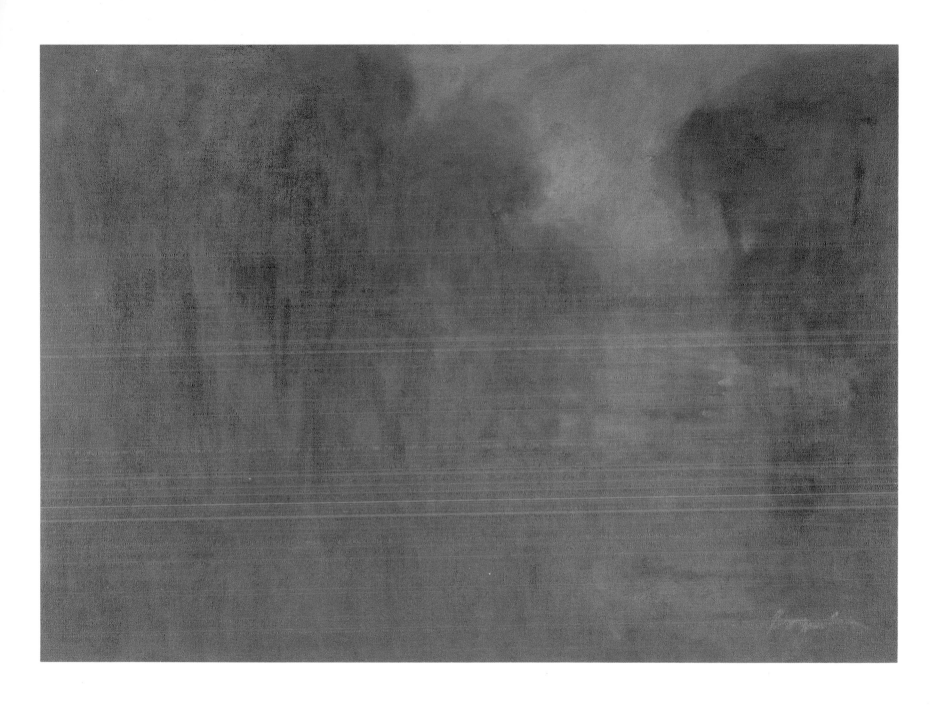

SLIPSTREAM, Oil and acrylic on cotton, 21 x 30 inches

I would say I have become a native to the memory of place. It is *mambo, sofrito, y cafe Bustello*. It informs the depth of my visual language. My work is an attempt at synthesizing experience. I've lived in New York City for thirty-seven years, and now I find myself at the beginning of an adventure outside of a place which has been home. I find myself looking for a means/symbols to express that relationship. The further away I am from a seemingly familiar place, the more objective I can be about that experience. I find that my work arises as a need to clarify that space between the familiar and the unknown. Traveling becomes its own dynamic. It forces me to reinvent my sense of place.

I am drawn to spaces that are uncluttered and look out to a landscape. The image or reminder of a "home place" is always with me. The work becomes a conduit, an attempt at bridging a gap between the familiar and the mysterious. I am drawn to nature. It is very inspiring. It doesn't talk back in familiar ways. I grew up in the Fort Greene Projects in Brooklyn. I spent a lot of time looking out of windows, imagining a way out.

I am drawn to the concept of change as reflected in seasonal change. Growth and development are critical to our development as human beings. Through my work, I struggle with color, or absence of color, changing formats, intentions. As with the changing seasons, there is constant reassessment.

When I refer to place, there are always two places: Home and the Studio. The home is where I live, and the studio is where I think! At home we cook, clean, wash dishes and do the laundry. This is one form of physical interaction. In the studio, I attempt to project this activity of life onto my work. My physical interaction is with paint. In the silence of the studio, I can hear the birds, the dogs, the children, the trains. I can see the sky and clouds shift in color and shape. Sometimes, to get inspired, I'll begin the day dancing to an old salsa tape, usually joining in chorus, until I cry from the sheer pleasure of it all.

Candida Alvarez
New Haven, Connecticut

WASHING A DISH, 1986
Acrylic/gel on paper, 44 x 30 inches
Photograph: Dawoud Bey 29

The right place? I have to find the place that gives me my picture. Something has to set the place off. What? Well, two red roofs can set me off.

Now, I only paint outdoors if it is a new place. There is one exception: the figures on the beach. These figures, I know who they are; I know their names. These paintings I work on directly. No arranging, no fooling around. I have painted out of doors for thirty years, more than Cezanne, though less than Monet. More perhaps than any modern American painter.

What do I look for? A configuration, groups of shapes even more than color or light or subject…and I am a colorist.

Ah light! I grew up in New York City; it has great light. My wife is from Cape Cod. Autumn is the season with the greatest light on the Cape. It is the greatest. Who can explain light? The south of France has a dense light. The air has pigment.

What do I do outdoors? I never fish, never go to the beach, except, of course, to paint. I don't walk or swim. But I have painted outdoors everywhere, Oslo, Venice, the south of France, Mexico, everywhere. If I go out, it is only to paint.

Paul Resika
New York, New York

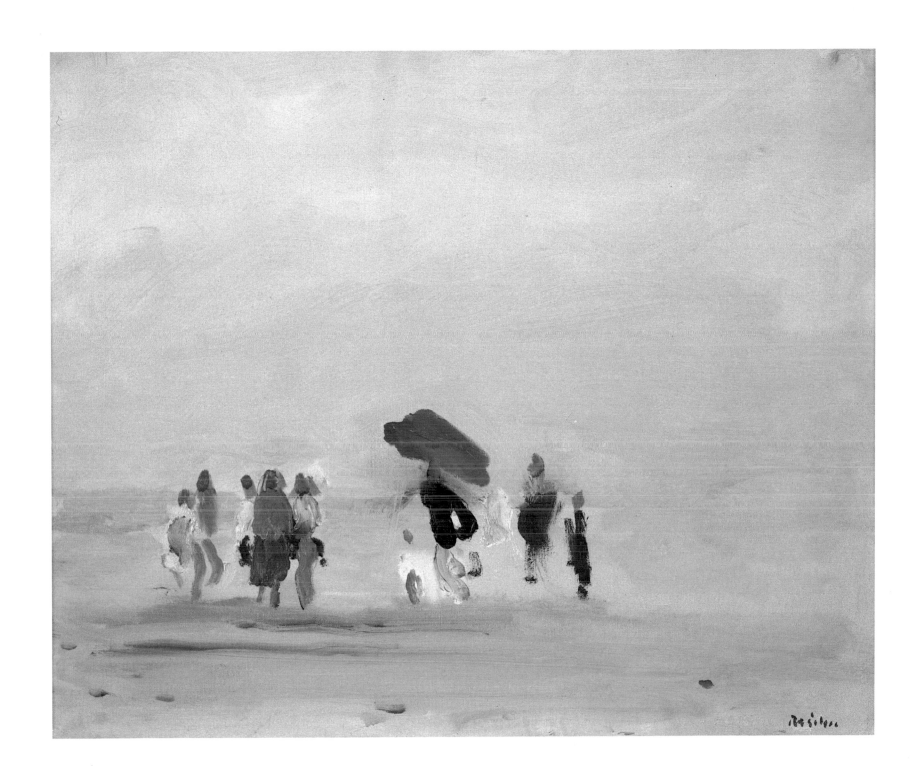

THE RED UMBRELLA, 1988, Oil on canvas, 20 x 24 inches
Photograph courtesy of Salander-O'Reilly Galleries, Inc., New York

Since 1963 I've been going to Gloucester and putting down real roots there, got my own studio, woods, gardens, harbor.... New York City is equally my home and is my "official" residence. My view of the Hudson is lively and never boring. The park below draws me, and I draw it every spring. There are gardens planted by neighbors that enrich the promenade nearby. I have roots in both New York and Gloucester primarily—other homes in Richmond, Virginia, where I grew up and still visit and where the southern light haunts and informs me, even now.... I get into the landscape more deeply in Gloucester, as I paint outside more and I grow the flowers I paint so often in still life. Even in New York I correspond with a gardener who plants in spring before we arrive in June, and I plan and shape and choose plants for color as well as for study—longevity in the vase. Gardening helps me connect more deeply with the feeling of growth—the reality of putting down roots. I study the architecture of the land as well as of individual flowers. All aspects of nature interest me: birds, plants, animals. Winter and spring on the Hudson in New York bring wild sunsets and iridescent ice flows. September and October in Gloucester are favorite months for sharp color and light, but who can choose between such beauties?

Nell Blaine
New York, New York, and Gloucester, Massachusetts

RIVERSIDE DRIVE AND PARK, 1970, Oil on canvas, 28 x 30 inches
Photograph courtesy of Fischbach Gallery, New York

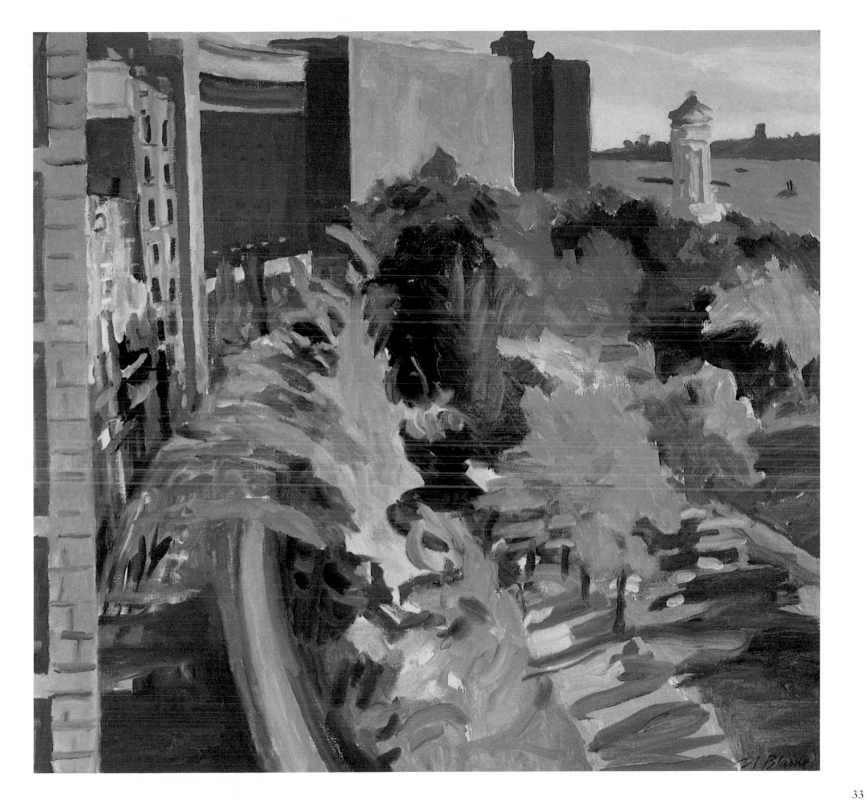

33

My knowledge of the earth is experiential. I don't know how much it has to do with expressing ecological fact—perhaps more the living of it. One might be native to a diversity of places—lands, seas, skies. One might be native to the planet and secondarily to any one place that one visited long enough to become acquainted—a year, a day, whatever it takes. How much choice is there to being native? Does a place choose you? Do you choose a place? Does being there, season after season, year after year, have a value in itself? If one stands on one spot long enough, one may become a citizen, and one may need to be a citizen to protect the earth.

My responses to the physical environment are as important to the painting as the physical environment itself. Both are subjects. Extremes of day or weather are determining factors as important as the setting itself to whether the site will be chosen. It is the place in a moment rather than the place as an intrinsic value. I look for a certain kind of light. For instance, the bigness of silhouetted forms seen at night gives a place a power and beauty that might not be seen at any other time. Seeing the same place under different conditions—day and night, winter and summer, clear or overcast—gives an intimacy. That is what I experienced with the series done from the World Trade Center, for instance.

To own an idea or really feel comfortable with it I need to feel an abundance, or a sense of necessity, as when it comes round a second, or third or fourth time and insists. I think of the process of creation along the lines in Rilke's poem "The Initiation," which goes something like, "then you step out of your house, of which you know each bit, your house is the last before the infinite…." The process seems to be a combination of being used to and seeing freshly, or seeing in cycles of time or weather.

My art gives form or expression to a feeling for a place. My paintings are emotional responses. The interesting part to me is the interplay with the place. This is given form in the brushwork; the way the marks build decides when the painting is complete. The act is what is interesting, but one always acts as a native. I would say the appeal is in the embrace rather than in the depiction of the specific features of the place.

A couple of weeks ago, tender yellow-greens and pinks and reds were emerging in all the wooded areas, with the occasional strident yellow of a forsythia bush. The weather was damp and gray. We cut the grass for the first time, and there were mingled smells of damp earth and cut grass.

Marcia Clark
Rifton, New York

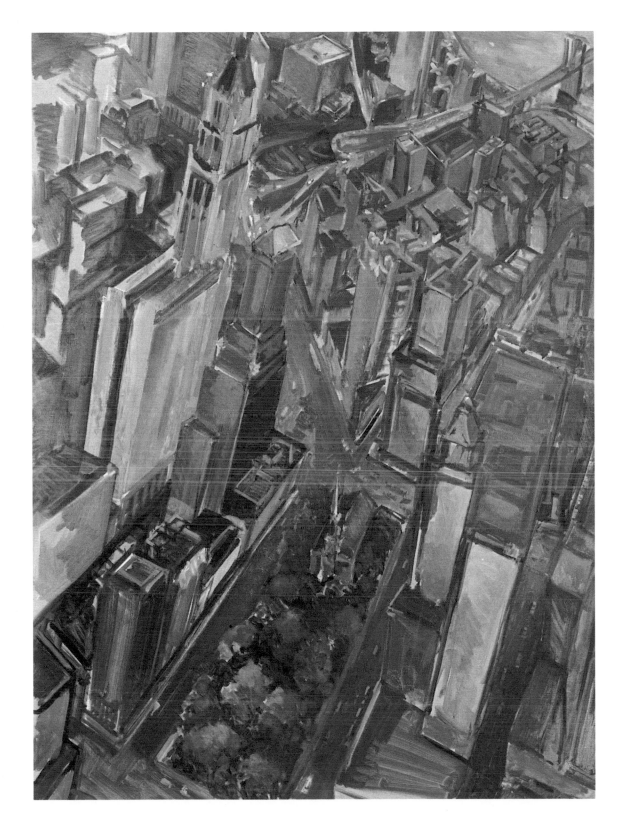

GRAY MORNING, 1984
Oil on canvas, 40 x 30 inches 35

I like a space with a north light and just enough height to give me distance from what I'm watching. In the Midwest this was a sweeping view of the shoreway, the parking lots, the stadium and Lake Erie beyond; in New York it is Chambers Street and a long parking lot looking north through to Reade Street.

It is not simply the physical environment that feeds me but an amalgam of my environment and my history. I grew up in a very small town in the rolling hills of western New York. But strangely, my aesthetic was never tempted by pastoral imagery. The memory of place that seems to have imprinted me came from the rides in the back seat of my parents' car through Lackawanna on our rare trips to Buffalo. There the serious factories, the incandescent furnaces, that thick, dirty, pink air and all those forlorn houses held me fixed with a richness of feeling and form. It was my earliest experience of a city.

I like the song of the garbage trucks at five in the morning. But I also like the sound of the apricot-brown mourning dove on the kitchen ledge. We are all in this together. I prefer the world as I find it, the world which is not dressed up and on its best behavior, but as it is on a Wednesday morning going about its business and unaware of itself. Here there is extraordinary beauty.

I can draw anywhere, but I can only paint where I feel attachment. I become native to a place by becoming familiar with the flow, the regularities of cars and people, of clouds and sun, of storms and sirens. I have eaten it with my eyes, gnawed on it in every light, at every hour and in every season until it is completely mine, completely consumed. This intimacy with a place makes it home. And then the most subtle of changes become obvious: a rare configuration of clouds, three viridian cars parked side by side, a momentary beam of light on a building. It is often these kinds of events which charge a painting.

I know the season by the light. It is the light, always the light. No two months are the same; no two days are the same. The light on a Monday is different from the light on Sunday. A favorite season? I like the marker dates, specific times, days, the human calendar as it joins the Earth's.

Living in the Midwest I ran regularly. Now back in New York I walk everywhere and chose a space where I was within walking distance of most of the places I like to go. The Hudson is a couple of blocks away, Chinatown nearby, Battery Park a healthy walk south. I have a small garden on the roof outside the kitchen and was reassured to discover that even in lower Manhattan four tomato caterpillars could find their way to lunch on our young tomato plants. We have two collies, two born-in-Vermont cats, and a twenty-four-year-old parrot named Albert W. Grokoest. It is impossible to be disconnected from the natural world with this extended family.

Catherine Redmond
New York, New York

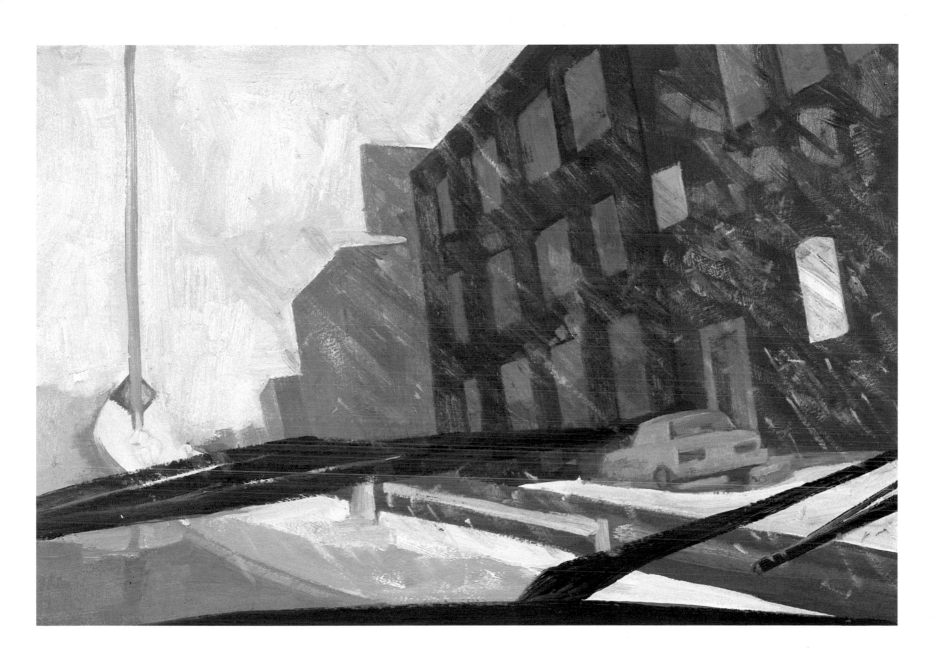

DISEQUILIBRIUM, 1987, Oil on ragboard, 6¾ x 10 inches
Photograph: Jim Hynds

In the sixties when I was an artist-in-residence at the Smithsonian Conference Center in Elkridge, Maryland, I was still painting images of New York City and Brownsville, where I was born and where I grew up. Even though I was in residence for eight weeks, those were my main topics. I became interested in textures and surfaces of buildings which I felt got to the character of the city. I started priming the canvas with a white sand called pearlite and started using collage material. There was a great deal of strife going on in society with the civil rights movement, and I was reflecting this in my graphic work and paintings: the tenor and abrasiveness of the city.

I had spent many years in Bedford Stuyvesant in Greenwich Village and in Harlem involved in artistic, cultural and political work as well as years in jazz clubs throughout the city, so I instinctively responded to the rhythms and nuances of the Big Apple. I have since developed this technique into multidimensional paintings including triptyches and totems using oil, sand, dirt, dry pigment, nails, pebbles and collage.

For twenty years I've lived and painted the urban landscape.

Here in the city I love the fall and spring seasons, as they are not too hot or too cold, and even the winter if it's very mild.

I physically interact with the city by using my large terrace which is on the twentieth floor and gives me a commanding and pictorial view of the city. My wife and I have plants out there, and we have friends over for dinner or whatnot or just to see the fireworks.

Vincent D. Smith
New York, New York

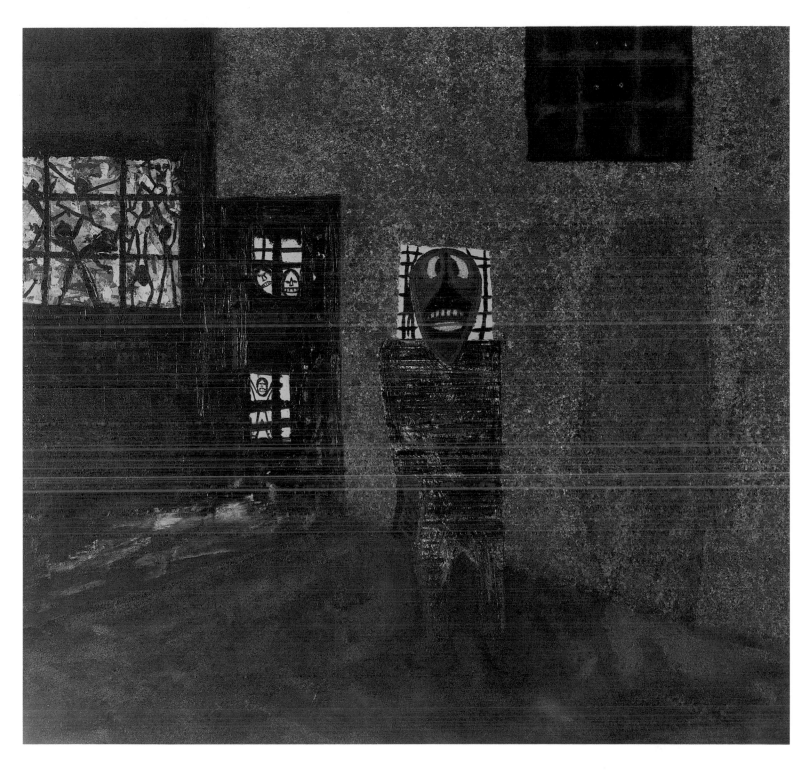

ATTRITION, 1972, Oil and sand on canvas, 44 x 48 inches
Photograph courtesy G. W. Einstein Company, Inc., New York

My own area which I have painted now for years…is changing. We have brown tide and over-development. Long ago I stopped painting only the beauty and eternity of the place. I have lost my belief in eternal nature. I think man is destroying it. The ominous crept into my landscapes and nature works first and then burst into images of ravaged sites, dumps, billboards as icons, memorials, reminders of what existed. My most recent paintings are black, tattered billboards in a wasteland.

Janet Culbertson
Shelter Island, New York

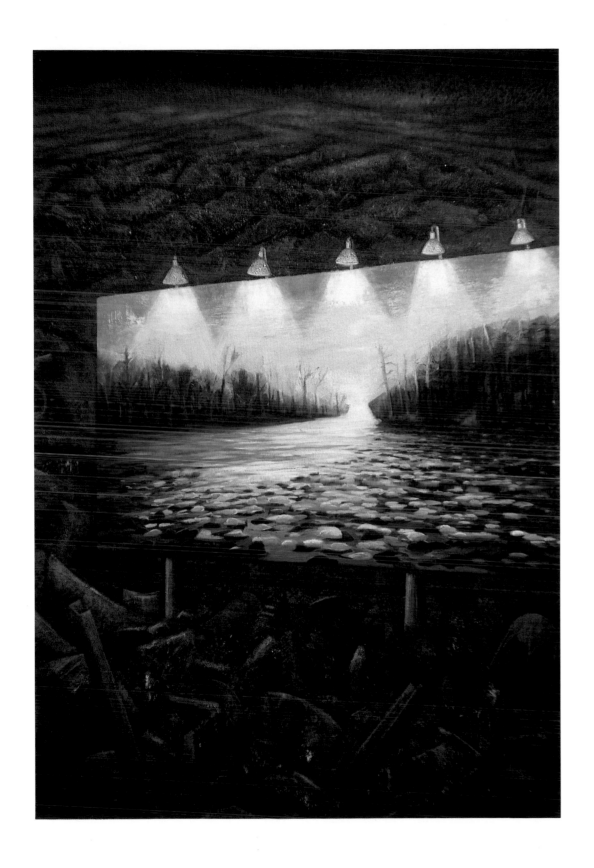

DESIGNATED SITE 2, CRAB CREEK, 1991
Oil on canvas, 48 x 34 inches
Photograph: Noel Rowe 41

After fifty-two years I doubt that there is much about the light, the coming and going of the seasons and the human activities that accompany these changes, about our birds and our weather and our general geology, that I don't know.

Until quite recently, this was a place predominantly occupied with farming and fishing: quite natural when you have some of the richest and deepest topsoil in the world going right down to the dunes and the Atlantic Ocean. At the same time, since at least the second half of the last century, there had also been people who came out from New York City and nearby points to spend summer months at the shore. They were a minority and lived pretty much in their own enclaves.

Now that has changed. The minority have become the majority, the background has become the foreground and we are a resort suburb. I hope I will be able to adjust to this change and some day paint this landscape, in its changes, with the fervor and regularity I once applied to it. I paint outside in the field much less now and have not worked off our own property in the past seven years. I paint more closed views. Many, if not most, of the open panoramas have disappeared; I can rarely react freshly to those that remain.

I work inside more, at other things, and wonder if I can be the sort of painter who will be able to use the skills and knowledge so slowly developed over twenty years to mine further, perhaps differently, a landscape I once loved.

Sheridan Lord
Sagaponack, New York

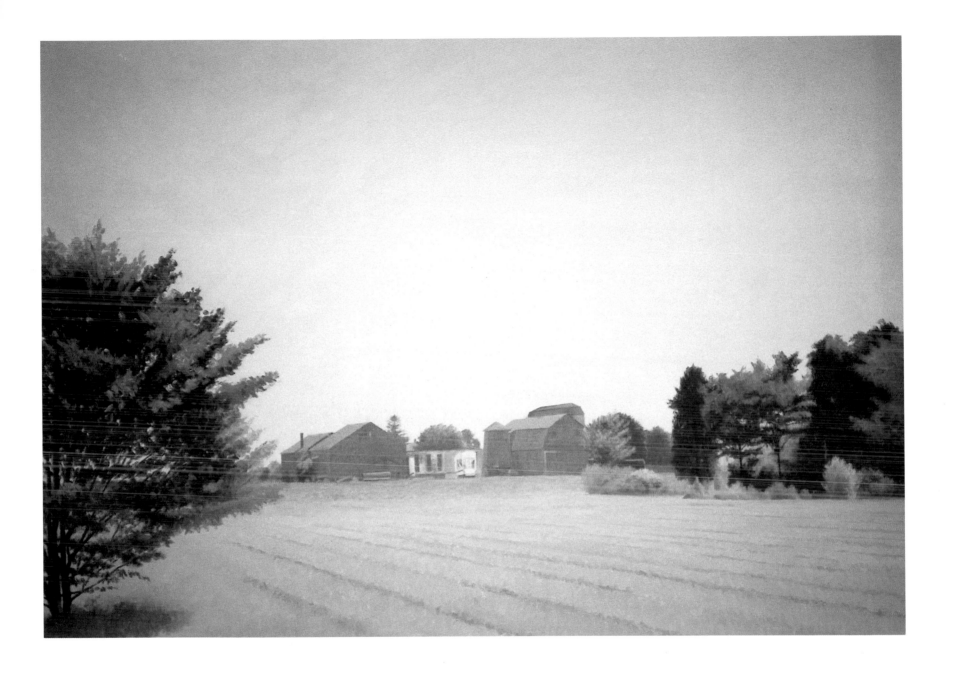

SUMMER, 1990, Oil on canvas, 32½ x 47 inches

I seek a sunny place with earth, trees, water and privacy. I am most energetic when the sun is shining.

My art may not show the place I live in the form of landscape or as an interpretation of the landscape: instead, it expresses the way I feel in my heart, which is so deeply nursed by the environment I live in. I love where I am, and this peace of mind seems to gear my work to be more the expression of a celebration of life.

I simply love all four seasons like an idiot and anticipate the change of seasons year after year.

The spring fills my heart with friendliness.
Extra enthusiasm comes with summer.
The fall is to reflect on my footprints.
The winter brings warmth regardless of the coldness outside.
I feel so rich and content when I cuddle up with my dog in my warm bed and read some books or make some sketches for artwork.

The circle is getting shorter and shorter as I get older, though. Damn!

Every spring I cultivate my small Japanese-style flower and vegetable garden in my front yard. I am planning to fill my yard with almost too many flowers next year. I said this last year and the year before, too.

I religiously take long walks with my dog in the woods every day. We say "Hello" to strangers, strange dogs and other animals. My dog swims in the stream and shakes his body right next to me with a big grin. Unlike hardworking joggers with Sony Walkmans in the woods, I simply do and think or not think whatever I feel like and it's a lovely time for us.

Kazuko Nagao
New City, New York

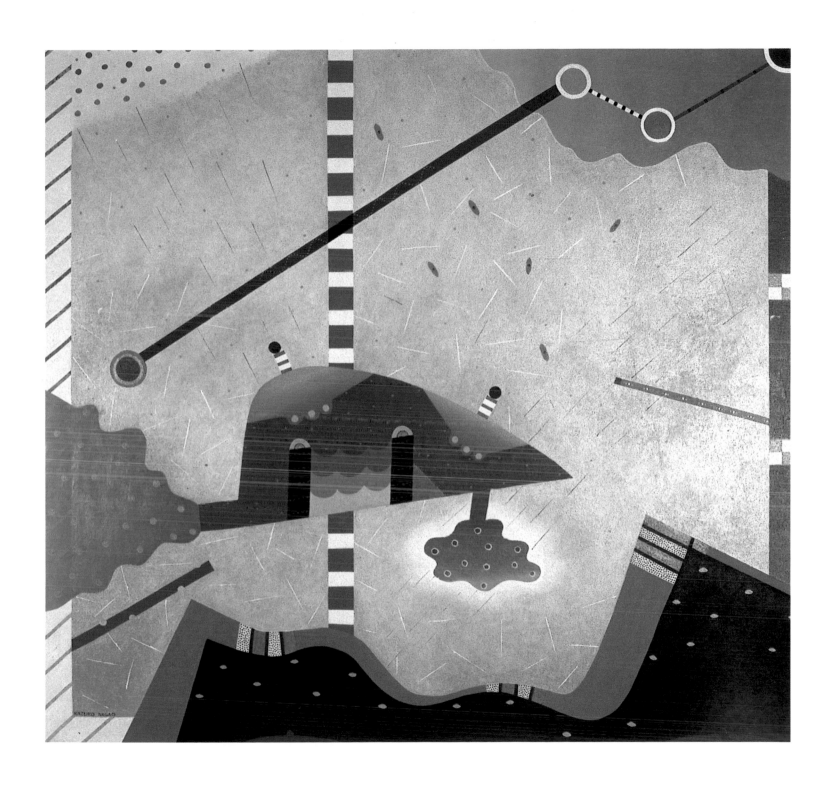

SEEDS ARE DELIRIOUS, 1991, Oil on canvas, 48 x 52 inches
Photograph: Sal Cordaro

I have always gravitated to long views, from my earliest landscape paintings. I find them to be more specific than so-called intimate landscapes. The further away I get, the less general the landscape seems to me, odd as that sounds. A close-up can be anywhere. It is preoccupied with detail, which is ultimately personal and less concerned with nature…the early twentieth century modernists could handle that dichotomy with vitality. Our contemporary realists don't handle the personal very well.

I am certainly a bona fide native to my place. Sadly, this place is shot. Because I know it so well, I can find ways to isolate the remnants of this once beautiful place and go paint them….My painting is tied to the outdoors all year 'round. There are days, of course, when I am forced to work inside, but that is rare. I am out nearly every day. I like working in inclement weather conditions—it speeds up my painting, hones the mind. Knowing how to dress for winter painting is important, but planning what you are going to accomplish based on weather conditions is as important as anything.

I end up loving the spots which have generated large bodies of work (fifty paintings or so). There is an initial attraction to a place, certainly, but only after the work has been finished does a bond between me and that land which I have exhaustively painted come to exist.

Joel Corcos Levy
New City, New York

TENANT'S HOUSE, DAVIES FARM, 1992, Oil on canvas, 30 x 28 inches
Photograph courtesy of Babcock Galleries, New York

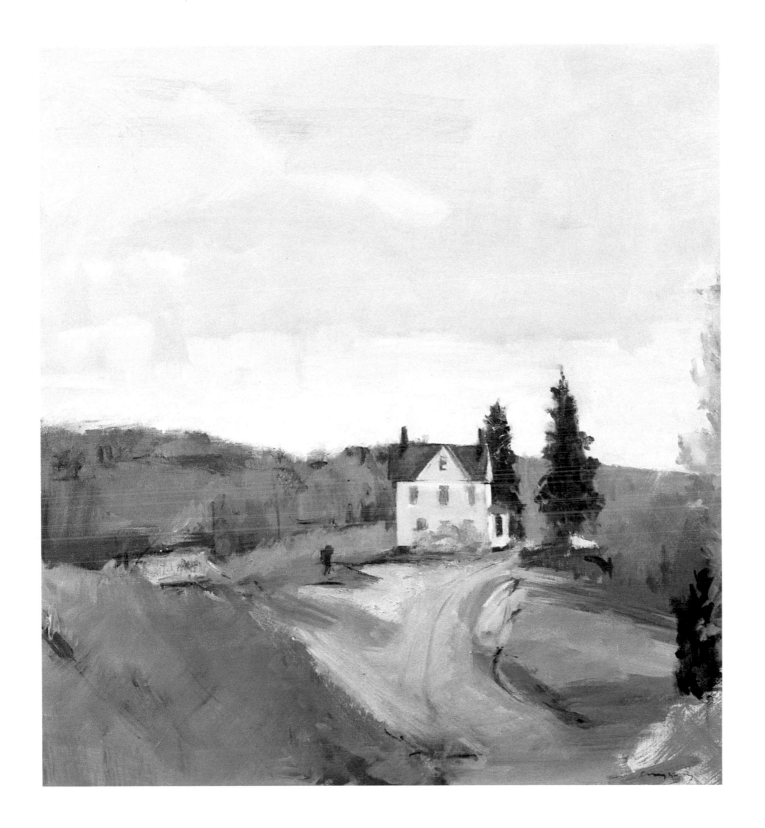

On our way to Monhegan Island, located off the coast of Maine, we have become accustomed to seeing a sign at an onshore farm stand. "Native Corn," it says. What does it mean to be native to a place? To be native does not necessarily mean that one originates in a place, though that certainly helps. We become native when we learn how to care for a place, to know when a new season has edged into our location, to know the light has changed, to know the sequences and patterns of arrival and growth of birds and plants. We become native when we identify with our home territory, when we know back roads and short cuts, when we are known in our local post office. We become native when we understand nature's indicators, how when some plants blossom or fruit, it is time to plant particular seeds.

We become native to a city when we feel at home walking, when we sense that we belong to a neighborhood, when we ride a bike or bus or subway and feel those modes of movement to be an extension of our legs. City natives know when streets rise or fall, when subtle grade changes spell important differences for running or biking. We are native when we know which store opens, and at what time, when the morning newspaper has arrived, either at our door or at a local cigar store.

Native, then, describes an act of becoming. Time, familiarity, habit, ritual, a kind of deep knowing—all these are parts of the process of becoming native. We have lived in Congers in the lower Hudson Valley for thirty-four years. We have gardened for almost that long, digging deeply, lofting the earth according to French-intensive, biodynamic principles, adapted to this climate. I take pride in my skills as a compost maker (the pile often reaches an internal temperature of 140 degrees). There are no assurances in growing vegetables, however, only growing knowledge based on experience which prepares one to be resilient, inventive, persistent, patient and, ultimately, humble before nature. We dig, plant, nurture and harvest, all as part of the flow of season, climate and place.

The artwork shown here is a response to the heaviness of midsummer, to those days in the garden when high heat and high humidity combine with the full efflorescence of plants to create a choreography of color and weight.

Alan Gussow
Congers, New York

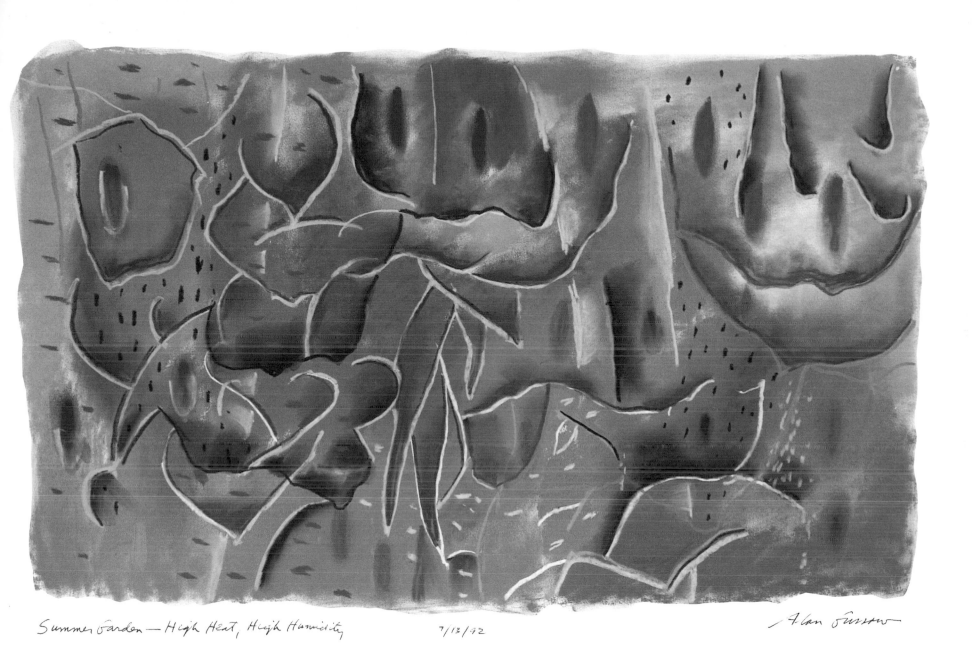

Summer Garden — High Heat, High Humidity 7/13/92 Alan Gussow

SUMMER GARDEN: HIGH HEAT, HIGH HUMIDITY, 1992, Pastel, 25 x 38 inches 49

We consider ourselves natives of the Catskills. Some of Judy's ancestors have been here since the late 1700s. We spend several months on a painting (needing) time to absorb the many changes and subtle nuances of the place. Often the feeling of place is realized rather than a definitive recording at a given moment. We anticipate all seasons with pleasure, but particularly spring and all the new life. We can work outside again after having painted in the car or studio or out the living room window. We have a vegetable garden...and bees. We watch birds in our yard, bluebirds, hawks, falcons, a great blue heron and even a golden eagle. We have also had bear in our yard.... A real pleasure is watching the sky. We are blessed, so far, with a dark enough sky to have beautiful stars all year. The memories of looking up from a blanket and becoming lost in an August night or the contrasting crystal clarity of a winter sky while out getting wood are equally cherished.

Judy and Doug Alderfer-Abbott
Willow, New York

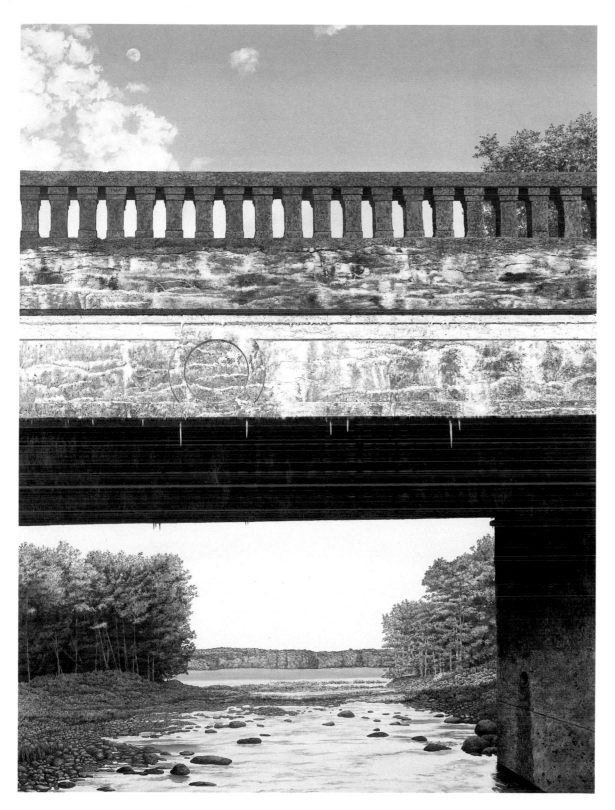

BRIDGE OVER THE BUSHKILL, 1987–89
Oil on canvas, 60 x 45 inches 51

Place

steady stepping lower
the interior
close and formed
looking at the surface lines
sight moving outward
rocking at the expanse of distance
and above wind moving in the deep half-domed space of blue
crossing patterns as I enter
pulling against my direction
brightness holds my silhouette
in each moment's liquid middle
sighting locations over my shoulder
to extend and put just below
then rotate right above left
tipping the edge for laying in
without sound
again
propelled barely above the moving skin
in my gliding shape
again
turning to look where I was headed
going where I came from
listening for shapes to avoid
the heat close on my knees and face
my head back cooling in the now shade of me
the low damp smell of familiar shadows
off to the side
as they approach from behind
and grow into spent signs
on remembered levels

Alan Cote
Kingston, New York

SERVES AND WHAT SIDE HE TAKES FOR GOOD GROWS WILD AND WIDE, 1991, Acrylic on canvas, 18 x 32 inches

Three years ago my family and I settled in the village of Middleburgh, New York, north of the Catskills in the Schoharie Valley. After considering possibilities in an area covering two states we felt guided to this place. It is hardly surprising to us that we've come to love this valley and to feel that we belong here.

Waking to the morning light, the first thing I often see through a bedroom window and across the village is a house which belonged to my aunt, the house where my mother was born. Up the street in an incredibly Victorian cemetery stands a grand red granite monument bearing the names of relatives I knew. Driving through town I unconsciously pick out the houses where aunts and uncles lived and the fields they once maintained. It is impossible to think of these people without wondering what experiences and feelings about this place we might hold in common.

All my relatives had a collection of stone-age implements picked from the fields. How very often I am aware or reminded of those indirect descendants who inhabited this valley for thousands of years. There is a mountain in the heart of the valley which was decapitated by a glacier before anyone lived here. The mountain was left hanging with its sheared cliff-face exposed to the swing of creek and sediment winding up into the distant Catskills. From the cemetery the profile of the mountain appears like a classical nose resting prone on the valley floor. Recent archaeological digs have confirmed evidence of Indian villages at the foot of the escarpment. From the rock platform at the cliff edge there is a view that forever changes the way one thinks of this valley. The earliest natives must have been intimate with this place in ways hardly imaginable today. I cannot help feeling that this mountain must have been sacred to them. Perhaps being native is partially a condition of being sensitive to the human history of a place.

Unlike the bedroom community I grew up in, people who inhabit this valley generally live and work here. The culture feels genuine. There seems to be a consistent correlation between the purpose for those being here and the welfare of the valley. Farmers continue to work the rich fields as in revolutionary times, a period when this was the edge of the wilderness. Still relatively remote (in a much different sense), the Depression, which left many a rural town in shambles, has not stopped activity or progress here. One is aware of the past beneath the aluminum and vinyl cladding of early architecture. The culture here is primarily dependent on the influence of nature's seasons and cycles. This influence and the haunting beauty of natural events in the valley are widely appreciated.

Driving while on visits to Schoharie Valley with my family as a boy was a process, an event that was both unusual and exciting. It is the same for me even today. There are very few roads or "doors" into the valley. The few accessible routes through the hills give a definite sense of containment and intimacy. The character of the landscape shifts slightly and one enters a different world. Privacy and definition of space are ingredients agreeable to my sense of becoming native to a place. One is drawn to particular kinds of environments out of need.

My most successful works (to me) are those paintings which indicate how I feel or interact with a place. The first year of painting in this valley was primarily one of exploration—walking, driving, discovering, looking, making notes on maps, talking to people, walking their lands, writing and frequent sketching with oil on panel. I painted everywhere, getting to know the various branches and hidden pockets of the valley and what each had to offer.

One of the joys of working here is being able to witness the radical contrasts and eventful nature of the seasons as well as the more subtle peculiarities and patterns unique to this area. Life here is traditionally influenced by natural phenomena—by moons and frosts, floods and the like. Observing the earth and skies and the telling events of the season are a kind of watch and calendar for many of us. Much of the enchanting nature of the valley comes with the great mists and fogs that scarf the hills. They're often good indicators of the season and even the time of day. Clouds running above the valley are noticeably different from the more blocky variety which can be simultaneously observed six miles to the north, where the hills drop away toward the Mohawk River. Elevation can mean the difference between snow and rain and can yield visually striking effects. Friends living five hundred feet above the valley floor plant their gardens a month later than villagers below.

During those early boyhood visits to the valley I remember dreaming what it would be like to stay on, to live in a place surrounded by these hills. My family and I now live in a humble Main Street house—"the eye-doctor's house." With it have come domestic responsibilities as well as opportunities to further establish our sense of belonging, of becoming native to this place. As a result, life this past year has been much more village oriented, while establishing our home base. Much time has been devoted to the rebuilding and studio conversion of a long outbuilding. In front of the studio, raised garden beds have been established with vegetables and perennials that we grew from seed. From the yard we look out across narrow village lots sporting elderly lilac and apple trees, fiddlehead ferns, tangled grape vines, peeling

gothic-revival cornice work, a clothes pole, and the brilliant blue line of a neighbor's swimming pool. A most recent painting incorporates all of these elements. Being native is a perpetually compelling task.

David Coughtry
Middleburgh, New York

VILLAGE TRACT, AUGUST, 1993, Oil on canvas, 30 x 46 inches
Photograph: Lori McAllister

One becomes native to a place when he becomes intimately familiar with it. To appreciate our environment is, I believe, a learned experience. I use the word environment instead of nature because I don't believe it is necessary to appreciate nature in its pure state, if such a thing still exists. My paintings do not always celebrate the picturesque. I am more attracted to areas that have been altered, violated, by us. Since I am part of that which disrupts nature (and we all are), it is this relationship and all its associations that I immerse myself in through painting.

When I first began painting as a teenager, I discovered the work of the Ashcan School, and viewed my surroundings through their eyes. The town I grew up in, located on the banks of the Hudson River twenty miles north of Albany, was going through a period not unlike what the country went through in the nineteen thirties. The industries that had nurtured the town, the railroad and the paper mill, were essentially gone. I painted all the back alleys, abandoned apartment buildings, the broken-down coal sheds. I wasn't painting the people, as many artists of the social realist period did. I was more concerned with the environment they created, and the place they were in the process of neglecting. I felt an affinity with my surroundings. This was, and remains, the catalyst for my painting.

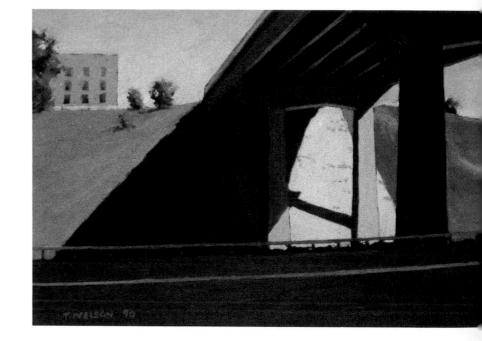

Constable said, "I have always succeeded best with my native scenes." He thrived on his intense love of his native Suffolk with its "willows, old rotten banks, slimy pasts and brickwork." It is precisely his approach, along with some aspects of the pre-Raphaelite period and the writings of Ruskin, that has influenced my painting the most during the past ten years. I feel fortunate to be from an environment where both man and nature co-existed without one blotting out the other.... My actual firsthand experience and knowledge of my local landscape remains my primary concern.

Right now my paintings are focused on the area immediately surrounding the city of Albany where I live. This area, where nature gives way to concrete and asphalt, is a myriad of roadways and highways that connect Albany with other places. Here I have found a catalyst for what is to me a kind of romantic response to my environment.

I grew up near the Hudson and now I spend many hours a week on its waters in my homemade wood and canvas kayak. The kayak is the ultimate craft for intimate exploration. To be in nature, to be studying it, is as important as the act of painting itself.

Tom Nelson
Albany, New York

UNDER NORTHERN BOULEVARD, 1990, Oil on masonite, 9 x 32 inches

As a child growing up in the Southwest our family was often on the move. My father was in the military for twenty years, and within that time I moved a total of eight times, from the age of two until I was thirteen. As child of three, family was always important to us. Going home to my grandfather's house in southern New Mexico to be greeted by numerous cousins, aunts and uncles, we felt this was the home place, where our roots were. When I think of this time, I am flooded with memories of going to the Mescolero Apache Reservation for the feast day, when we celebrated the puberty rites of young maidens. This was also a time when my mother's clan would come together to camp out, cook and eat incredible New Mexican food. While the adults spent time catching up with family gossip, my cousins and I would spend our time running through the forest. My memory is also merged with my father's side, where I had ten uncles, their wives, more cousins, my grandmother, Pearl Bigfeather, and my grandfather, Jesse Osburn. Each year we would make the trek out to eastern Oklahoma to hear stories of my father's childhood, to visit the stream where he learned to swim (and nearly drowned), to rummage through the family trunk and ride into the country to discover where my grandparents had their farm during the Depression. I can still see the property and the remains of a chimney made from river rock.

Although we spent many years roaming through the country, I always felt New Mexico was my home and still do. What makes up a sense of place for me is family, people, diversity of culture, food, tribal traditions, adobe buildings, the beautiful blue skies of New Mexico high desert, mountains, red and green chili and people with open minds who are involved in social and political issues.

Living in Troy and working in Albany over the last two and a half years has given me a sense of isolation more than a sense of place. Perhaps this isolation is the sense of place. To be without all the familiar things I mentioned above has led to this unfamiliar way of life. My work serves as a metaphor for tribal people in their own home land and the feeling of not fitting into the landscape of "American" society. In my eyes the Statue of Liberty is not a symbol of liberation but one of acculturation and bondage. "Liberty" looms out, sending a message across America and the world, "liberty and freedom for all!" As I traveled across the United States, I found racism and ignorance in many of our "fellow" Americans.

My work is about trying to reestablish native people's history in the North American landscape, to rewrite our history in a visual sense and to take control of the Native American image by someone who is native. For five hundred years tribal people have been painted, drawn and sculpted by non-Indians. Through these representations we are often depicted as savages, or our traditions are romanticized, or we are expected to be spiritual earth-gurus. It is only through our own eyes and sense of place that we will truly be rendered as real people.

Granddaughter, I Am Teaching You was inspired by visiting my grandmother. She is a full-blooded Cherokee and is still very active for a person who will be ninety-eight years old. The image in the painting is set as if we are riding across the United States by rail. The piece is about relocation and oral history. My grandmother's own mother, Susie Six Killer-Houston, was removed from Georgia during the Trail of Tears along with her family. Only she and her sister survived the walk to Indian Territory, which we know today as Oklahoma. This piece is a tribute to our survival and our history.

Joanna Osburn-Bigfeather
Troy, New York

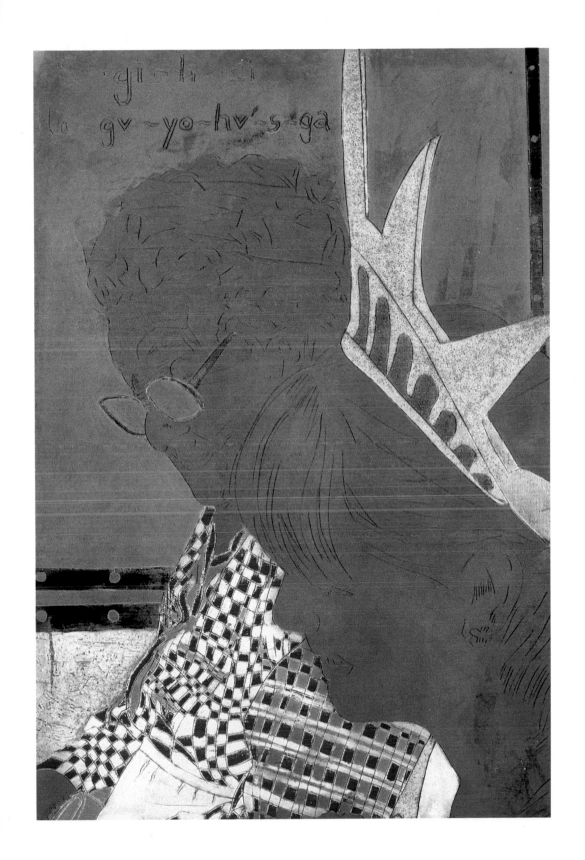

GRANDDAUGHTER, I AM TEACHING YOU, 1993
Clay with raku glaze, 24 x 17 inches
Photograph: Neil McGreevy

Too often in the late twentieth century we race past places, never giving them the viewing and experiencing they deserve. Is it any wonder so many people these days seem to feel a sense of loss—spiritually in the broadest sense and otherwise? We are too detached from our surroundings, our histories, indeed, ourselves. Curiously, although my father's family is Dutch/German, it is through my mother's English family that I have ties to upstate New York. They lived, fought, died, are buried and enshrined in the region. Although I was born and raised in the Midwest, my coming to upstate felt like a virtual homecoming, separated by years, miles and generations.

Upstate New York is remarkable for its variety. There is an abundance of color here, punctuated by a great deal of change. There is a vastness to this land (not found in New England); there's a lot of water, deep forest, mountains and open plains. The skies can be magnificent. The light is never as searing as that of my upbringing. Yet this is a region that seems to combine the essence of many others. It truly is an empire. There can be a brightness to this northern region, and there is also an extraordinarily haunting darkness.

Levels exist between seasons, that intricate line, becoming, being undone. I'm fond of all the seasons. Spring is laden with so much potential that it can be dangerous, even frightening. When I lived on a farm in the Midwest (my wife and I moved back for a while after we'd lived in New York City for five years), we'd brace ourselves for the spring, knowing that as it renewed life, unforeseen storms would likewise come and destroy and leave scars on the land and in lives, scars that were not there before. Spring is soul-stirring. Although I dislike heat and sweating, summer tends to be a very productive time for me. Fall (which is incredible in this part of the country) is so wonderful I have a hard time accomplishing much in the studio. It's a fantastic time to be outside. Fall is spectacular and a real hoot to paint sometimes—as with a wild party, though, you've got to be careful not to get too carried away. There is great beauty to be found in the quietude and delicacy of winter. There are more color and life in winter than most give it credit for, seeing where the animals have been, breathing the crisp sterility of the air. The Indians (i.e., the indigenous people of the region now called North America) said one must walk gently in the winter not because one risks falling on the ice, but because the earth is sleeping. However, I don't paint or draw the winter as much as I once did. I'm growing older.

I walk, putter around the yard, dig in the soil, plant trees, flowers and shrubs. I work on the house sometimes in order to become more a part of it. I love boats and have sailed since I was a boy. Sailing is intoxicating: the feel of the wind, responding in kind, encountering the prenatal sensation of the movement of the craft. It's exhilarating! Saying that I'm currently between boats is like saying I'm between marriages—or jobs. One learns a great deal about life and about oneself on many levels when sailing. Sailing is to the water what walking is to the land. I also fish. I won't tell you where. Trout still populate many upstate streams.

Walter Hatke
Schenectady, New York

THE MOHAWK RIVER ERIE CANAL LOCK AT VISCHER FERRY, 1992, Oil on canvas, 22 x 68 inches
Photograph courtesy of Babcock Galleries, New York

The ideal setting for me seems to be my living space, not a studio away from where I live. The ideal time is during the day, although a piece might get finished in the evening. I like my work to be around so that I can see it and think about it over time. Feeling comfortable in a setting is important to me when I want to do artwork. I can establish a comfort level in many places, however. I once worked on a piece flying between Albuquerque and New York. I've produced art in the home of a friend when it was necessary and I've worked in a studio with a professional papermaker.

Today I live on a Seneca Historic Site. I am a Seneca and the site is located in the heart of the original Seneca territory. I believe the work I do is the product of where I live and all the forces that influence my life. My favorite time of year is summer. I love each of the seasons and often my work chronicles a particular time of the year. I like the transitional times between the seasons, such as late winter to early spring. The impact of a late snow on birds and landscape fascinates me. That time of transition makes a good subject for an artwork.

I'm a gardener. I keep track of seasons so that my planting is planned out. Concerns about the needs of my plants are ever present through-out the growing season. I like the work of harvest: picking corn and caring for it so that it will dry properly is good work. I walk outside over the trails that are on this historic site. I trim the plants growing over the trails. I pick the berries, and in winter I fill the bird feeders. All of these activities put me in touch with my surroundings. The earth is our mother; she provides everything that you and I need to survive.

G. Peter Jemison
Victor, New York

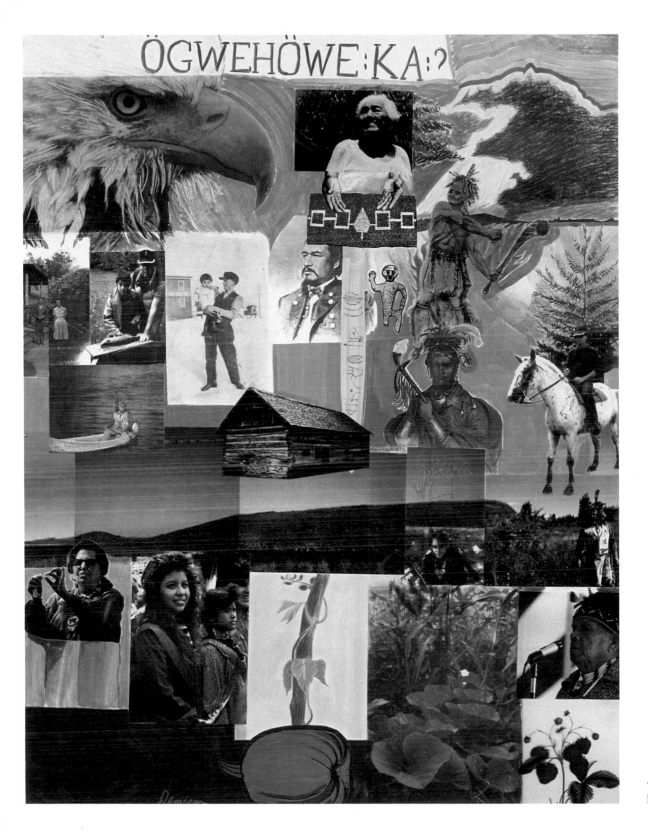

"ÖGWE ' Ö: WEH: KAA" (INDIAN WAY OF LIFE)
Mixed media, 50 x 38 inches

Certain places affect me in a visceral way that is almost unexplainable …they have a certain power that is more felt than seen…they are sometimes open, sometimes tangled and private. All are secluded, natural, wild…silent. Would I say that I have become native to my place? Of course. I am one with this piece of land as much as the wind moving the trees around outside my studio tonight, the trees themselves, the moss-covered rocks and immense changing sky overhead. How do we physically interact with our place? Organically …like the birds and other animals we share it with. We fell next year's firewood in December and January…. We know them, we know their names: ash oak cherry maple beech hornbeam; the names of birds, woodthrush warbler catbird night hawk yellow-throat wren, their songs and calls. Where to pick good wild apples, blueberries, blackberries, raspberries, wineberries. Fish rabbits deer grouse. Endless delight.

We built our house by hand to fit into, not stand apart from, the land it occupies…it looks like trees and changes color as they do in rainy or dry weather. The land supports us and we treat it with respect. We tend a large organic vegetable garden…we build stone walls and plant trees and bushes. We keep chickens and miss the sweet Jersey cow we raised from a calf, but not the twice-a-day milking. In fall and winter we hunt with bow and arrow and gun and waste nothing. What cannot be eaten goes into the compost heap…. Our life here is work, but it is work we cherish. We enjoy the labor and the sense of accomplishment and fulfillment. Completeness. Wholeness. We wish for nothing more.

Earl W. Lehman
Montrose, Pennsylvania

PEWTER GREY SKY, IRISH HILL, 1991, Mixed media on paper, 10 x 10 inches

It is the suburban settings, the congestion and compactness of these altered landscapes, where I feel most able to imagine and transform the physical environment into another world. The combination of architecture (particularly of the past century) and its relationship to the land provides a constant array of choices that are open to interpretation. It is particularly the middle class areas that give me the most stimulation, possibly because personalities are not hidden and one can see the variety of choices people make to define themselves. The color of a building, the surrounding vegetation, the architectural changes all supply visual information. With this visual information, I then alter my own spaces in the painting. Scale shifts, altered perspectives, exaggerated color and dramatic light are all conditions that exist somewhat, somewhere, but then I create my own place from the facts that surround me and change fact to fiction.

I feel I am truly a native of the suburbs. Raised in the suburbs of Cleveland and now living in the outskirts of Philadelphia, I am surrounded by a certain life-style. Not only am I familiar with the physical manifestations of these older neighborhoods, but there is an emotional component that I am connected to as well. There is a timeless quality to life—a calm, serene and secure feeling. But this can just be a facade. There is decay and deterioration of the older structures that reflects the fears, hopes and dreams of the people inside. All of this creates a mystery that I can use in my work. Maybe it is these dualities that keep me interested in these images. In truth, it is the connection that I feel to these places that gives me the inspiration and provides a vision that I do not feel in other places. My whole life I have been immersed in these places, and rather than fight them, I have embraced them and tried to bring meaning to them through my work.

As I write, buds are making an appearance; forsythia and Japanese cherry trees are blooming like crazy, sprinkling the landscape with yellow and pink. Color shifts constantly from season to season. Shapes are more abundant in the summer; lines are more visible in the winter. Seasons provide not just a sense of time, but also a sense of atmosphere and content.

My Garden. I have a flower garden that I am obsessive about. We have a small vegetable garden during the summer at our home away from home. This time of year, however, I find myself bending over, frantically weeding and moving plants, completely oblivious to the world around me. It is a constantly changing environment where I can have some control but nature ultimately decides. My children have their own little plots which they care for. At this point in my life, it is through the daily interactions with my children that I find myself taking a walk or riding a bike, the purpose being to share these places with them.

Celia B. Reisman
Merion Station, Pennsylvania

ONCE THERE WAS, 1992, Oil on canvas, 38 x 38 inches

There's a wood near my studio where painting thrives. It's a broken down place—fallen trees, stumps, skunk cabbage, oak trees, scrubby new growth and forest floor of reddish leaves. A fair-sized stream is fed by soggy trickles of dark water and a spring or two. It's wild, chaotic and irregular—you can't stand there and copy. There's too much and it's too crazy. You can feel it, see it. But to paint you have to invent it...I drag canvas through the brush, prop it against a tree, put the palette on the ground (hoping my dog doesn't step on it) and then the battle begins. I have lived in this spot for eighteen years—eighteen years of painting my backyard... I paint this tiny corner of the world. It's enough. I am as native as the trees or the deer...my paintings are shaped by the seasons and the hours. I paint sunrises because I live on a ledge of farmland that feeds downward to a small open valley with the eastern sky beyond: the morning mists, the early light and the mystery of the red sun. I seem to paint better in the late fall, the winter or early spring...you can see more without all the leaves, and snow seems to be a clarifier. Painting outdoors is no picnic—especially when you have a five-foot canvas—it's a wild adventure—the wind, the snow, the changing light and the numb fingers.

Eugene Leake
Monkton, Maryland

TURNER WOODS, 1990, Oil on canvas, 16 x 20 inches

My particular part of the world has been a necessity to the making of my work. Although I travel quite a bit, I have never had any interest in actually painting during my travels. (Of course, this seems odd to my non-artist friends.) I have no reason to depict the splendors of the Alps or the Rockies and have no interest in scenery.

Concerning what makes my particular place right for me – a sense of connectedness comes to mind first; an awareness of the march of time and who came before me. Whenever I begin work at the site, I think of the forming of the planet, the coming of plants and animals, the first people, who lived here for tens of thousands of years, the founding of Augusta in the 1730s, the eviction of the native people in the 1830s, the arrival of my great-great-grandfather in the 1840s from Ireland. In short, I feel I work in the land of my fathers; a land of blinding white heat, red earth, and an unending (I suppose I should say ending) variety of choking vines.

I consider myself a native to my place. I hope my art is an expression of this condition. I try to communicate what I feel are certain values of the landscape – values which are not necessarily appreciated by all of the natives of my region.

I anticipate a certain season with particular pleasure: autumn, not for the splendor of the color of the trees (which I can barely enjoy for being aware of the pitfalls of depicting such color), but for the splendor of the light – so pure, clean, and clear after the white, hot, hazy skies of summer.

I keep up the grounds around my studio (planted in the 1950s by my grandparents – camellias, boxwood, a few poor pines). I am an avid hiker, canoer, target shooter, guitar and mandolin player, firewood gatherer and sometime Native American artifact finder.

Edward Rice
North Augusta, South Carolina

FIG TREE #12, 1990, Oil on paper, 12 x 12 inches
Photograph courtesy Heath Gallery, Inc., Atlanta

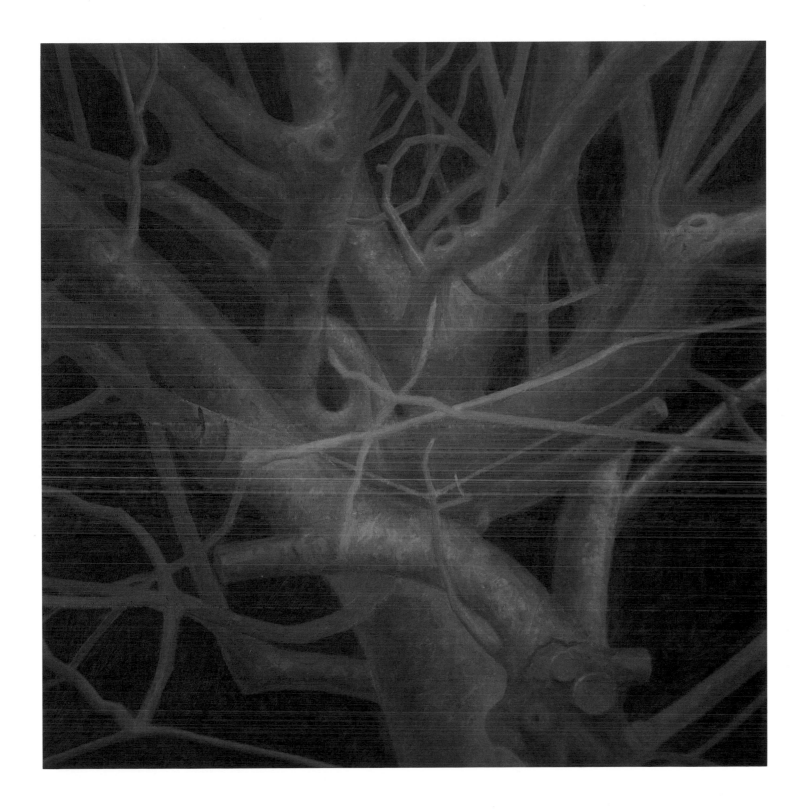

The goal of this book and exhibit is pretty clear, and it disturbed me, not because I don't think some of my work is appropriate, but because it forces me to think of feelings and loves that I've hidden away too often. I came into painting years ago to express a passion for places and people I've felt strongly about. To choose between the coastal works and the paintings from the woodlands is difficult: both are landscapes that have formed me. I love both for different reasons. The woodlands are the place of my youth, where I used to roam with a copy of Thoreau's journals and a sketchbook. The forests have held my imagination, the unknown forest, dark and verdant, beech and oak and hemlock, granite and rushing water, fields on the edges of woods. It's the landscape that showed me that there can be a poignant truth and mystery to try to find in an image. And yet the other, the coast, holds such a fascination, what Homer called that "damned horizon" that has to be confronted, that demarks earth and water and sky so relentlessly. I am much nearer it now. What did Melville say— that true places are never on maps simply because they are where we invest our hearts, and you do not invest your heart without being affected by the life and terrain and weather there. Each element, with your own dreaming of it, creates the sense of place. For the painter, it is investing yourself in the landscape and trying to see beyond the surface impression, committing yourself enough to know the place. I've always imagined that in painting a place I become, somehow, a part of it, and it a part of me, and that my understanding of the place is particular and unique.

Don Powers
Thomasville, Georgia

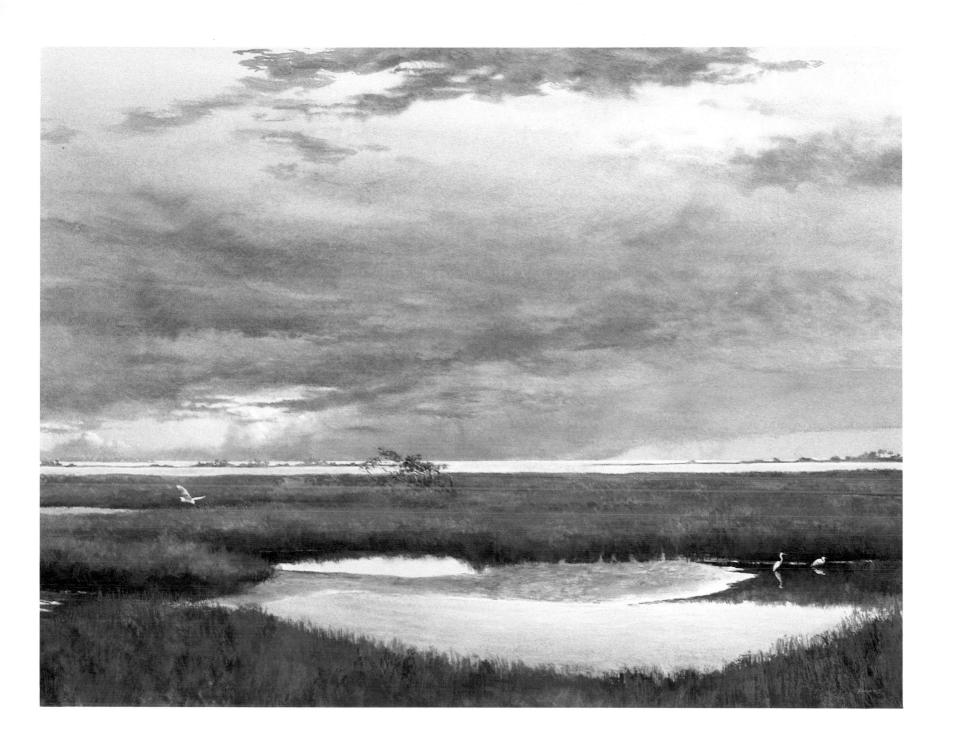

CAPE SAN BLAS, #2, 1990, Tempera, 28 x 40 inches

I am drawn to rural environments that afford a sense of space and silence and an opportunity to unobtrusively observe daily functions of others as we all pursue life's mission of work, love and belonging. Agrarian life allows me to experience how we work in harmony with the mysterious and changing fabric of nature. It is the small, but critical tasks of daily life that I find most stimulating and reflective of the quality of essential personal, community, and social values.

The visual experience of observing families working together in the field is a source of creative inspiration. How a man tills the soil in silent labor depicts a sense of purpose and functional movement that brings sustenance and well-being to the family and community. Such sustenance may be devoid of obvious possessions, but is vital to the family's well-being and survival.

I am acutely attuned to the daily life of the rural community and the rhythm of routines that require an innate sense of timing. My work reflects images of community and family life that range throughout the day, such as preparing morning meals, doing the wash, accomplishing the farming chores, finishing a day's work, and relaxing in the evening. Even the social and religious rituals of the rural community life such as baptisms, funerals, wedding receptions, and community dances reflect a sense of silent timing, dignity and pride which is an ongoing source of inspiration to my work.

Spring in a small southern agrarian community has always been my favorite season. A sense of hope and anticipation is conveyed that heightens my desire for discovery and experience. It is during the spring that I am able to most clearly discriminate acts of tenderness between family and the community. It is at this time that the land is tilled and the earth vibrates with an affection for life. Such affection is infectious and influences my use of color and a desire to instill my work with energy and vitality.

I approach my own environment as a silent participant/observer. Early mornings are often spent pruning the hibiscus bushes, watching the clouds give way to the sun, or having a quiet walk in the countryside.

Jonathan Green
Naples, Florida

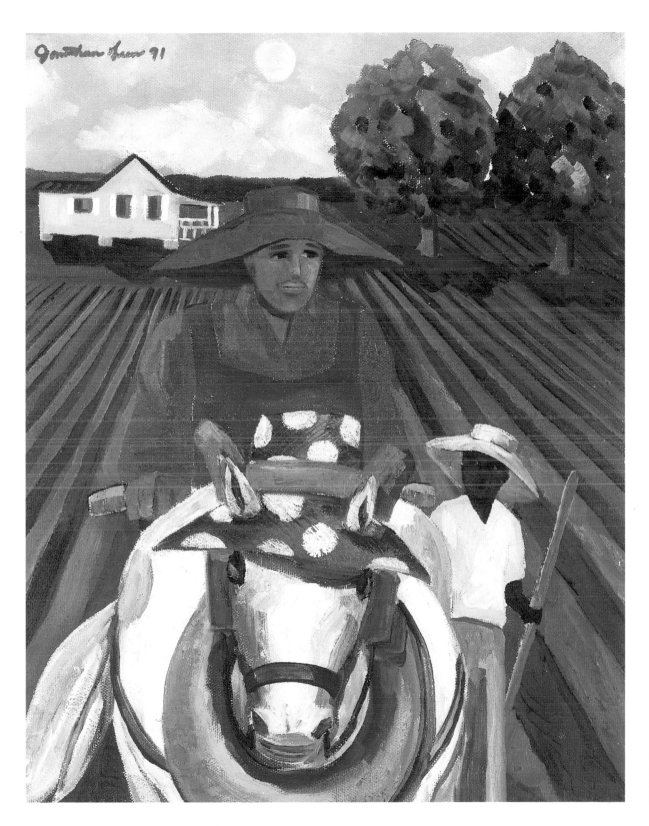

PLOWING THE LAND, 1991
Oil on canvas, 14 x 11 inches
Courtesy of June Kelly Gallery, New York
Photograph: Manu Sassoonian

The setting that is most conductive to the making of all my work is nature itself. Nothing can be compared to the wonderful feeling I experience every morning as soon as I open my windows and can see and smell the plants, the trees and the sea. Nature is what inspires me to create, to work. It revitalizes my spirit and helps me to communicate, through my art, the immense beauty that lies beneath a flower, a fruit, a setting. I travel a great deal and have always tried to stay in places where nature has a major role in daily life, so my work can be enriched. The time I spend in Tahiti, Spain, Mexico, Santo Domingo and now living in Miami Beach is all part of the physical environment that an artist who loves nature needs every day in order to create.

I have become a native of this area and love it. The sea and the weather are significant when I start a work of art. The light and colors of this part of the United States are almost tropical, and I feel here it is like home. I try to express all this color and light in my work. Here red is red and blue is blue; there are no grays, no halftones. Occasionally, these feelings convey the image of my roots and the tropical island, Cuba, where I was born. I know that I will always stay here, close to the beach, the sun, the Everglades and everything that makes Miami my native place.

Except for winter I love all seasons. I can tell very easily what season it is by looking at my work. I perceive summer as a carefree space where my work can explode with colors, light and harmony. There are no limitations in my work in summertime; ripe fruits, nude women sitting in a garden that reflects paradise, birds next to them singing the beauty of this time of the year. Spring and fall are more subtle, a little bit more sedative; my colors become a little bit less aggressive, but the influence of the place is there, never going away.

To take a stroll in the evenings along the seashore; to grow beautiful flowers and plants; to listen to all the birds singing when the weather calls for happiness; to take my canvas and colors and sit under a tree and try to copy what nature in all its splendor is giving us for free: this beauty and immensity is life itself.

Orlando Cabanas
Miami Beach, Florida

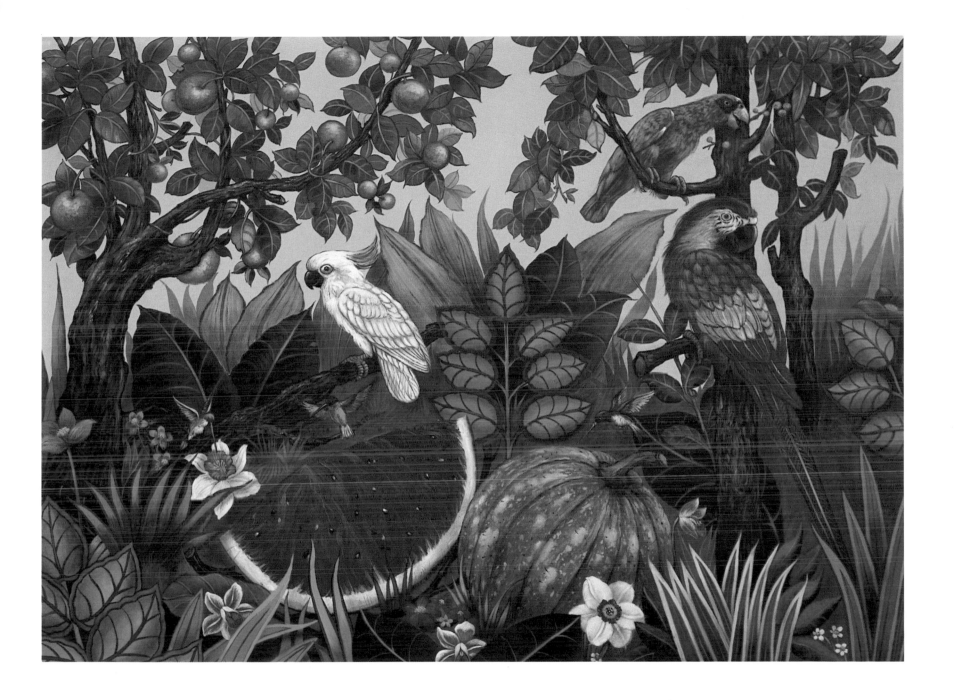

HOMAGE TO NATURE, 1992, Acrylic on canvas, 35 x 45 inches

For the past six years, I have spent five to seven months each year in Puerto Rico. I went there originally for health reasons and was immediately struck by the place: an island rich in culture and imagery that felt as if I had lived there a very long time! My response to this incredible place has been an outpouring of paintings that reflect its magical, mysterious and dramatic impact. Puerto Rico is struggling with all the critical issues that are of global concern, and the problems of overdevelopment and overpopulation result in environmental disaster and cultural deprivation. Yet, there is still great beauty and a strong native spirit that I admire in the place and the people.... There is pathos here, and heart. It is an island on the edge.

I find it stimulating and conducive to an art that goes beneath surface and exposes the underbelly of things. Certainly I have a sense of being native to Puerto Rico (even my name, Elena, is Spanish)....I am a sponge, a mirror; I soak up the images, light, feelings of the place, and although I may not fully understand what it is all about, I can use these things in my work—I am forced to see in elemental and more direct ways. I love the open-air life of the tropics: the art on the walls (the Latin way of telling the story), the landscape, the sea everywhere, the openness of the people and especially the early Taino culture. I feel its presence everywhere, even though it is long gone, vanished. I walk everywhere in the town where I live....I take boats to smaller islands...where I go snorkeling, see whales and dolphins and flying fish....I hike in the rain forest, watch for birds and see orchids and many other wondrous things....I am very physically interactive with the place, which has helped me greatly to know it intimately. I am fortunate to be able to incorporate these specific feelings and experiences into my art.

Elena Jahn
Culebra, Puerto Rico

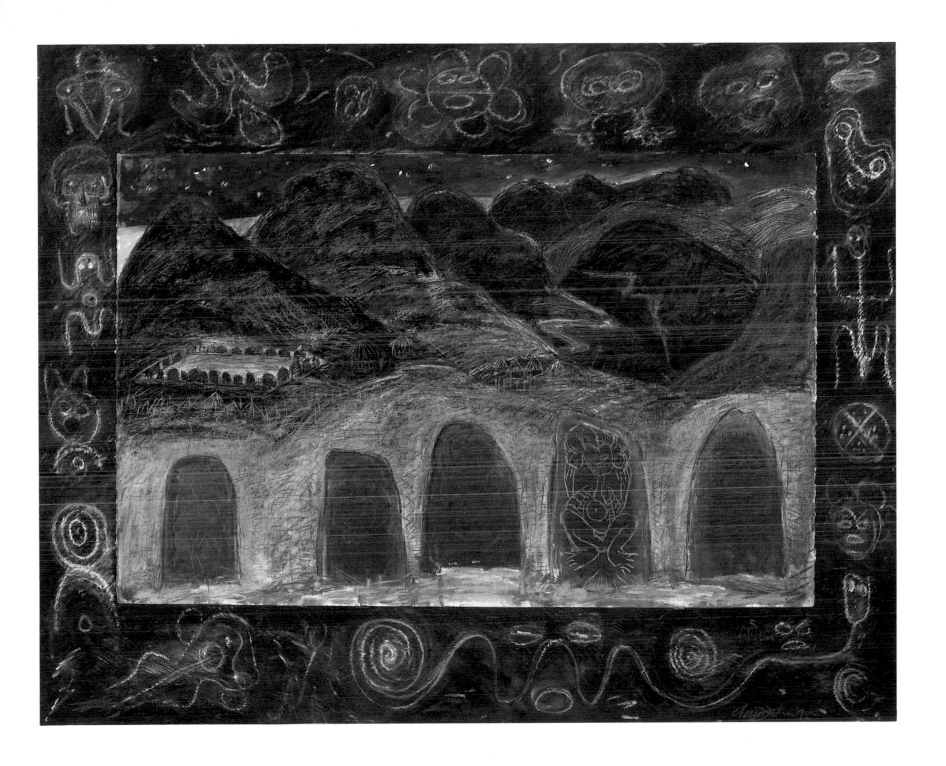

CAGUANA, 1991, Mixed oil media, 40 x 50 inches

Yes, I have become native to my current place of the past twenty-one years. It took me a long time to feel this sense of place here—perhaps because it was so different from the area of the country where I grew up. When I lived in Nebraska my paintings reflected a rural feeling. Having little exposure to the rest of the world, my paintings tended to be small in scale. Now, after twenty-two years in Kentucky near a large city, my work reflects a much more urban feel and has certainly expanded in size and scale. The paintings show the sense of chaos, the busyness, the constant state of movement. The architectural paintings of glass reflections in twentieth-century buildings of the old architectural wonders of the past century are my means of expressing this mindset.

Spring and fall are my times of the year. There is nothing quite as beautiful as the delicate colors of spring or the bold hues of a Kentucky fall. I use them in my work—the crisp, fresh greens balanced by the warm reds. Nebraska landscapes are expansive; Kentucky landscapes are lush, overgrown, close. In my nature watercolors, I attempt to portray this sense of closeness, intimacy, and isolation.

I take walks in town and when time permits in a lovely forest near Bardstown. When I was forty-one years old I started to pursue another lifelong interest—aviation. There is untold joy in seeing the bird's-eye view of the warm fall colors and spring greens covered by the Kentucky mist and haze, even though flying in hazy conditions is hazardous! The landscape has a contemplative aura about it, and yet a majestic sense at the same time. I have flown in the area enough now to be able to take pleasure in recognizing certain knobs and landmarks. I like the secure feeling of being native to the landscape, a particular place.

Jim Cantrell
Bardstown, Kentucky

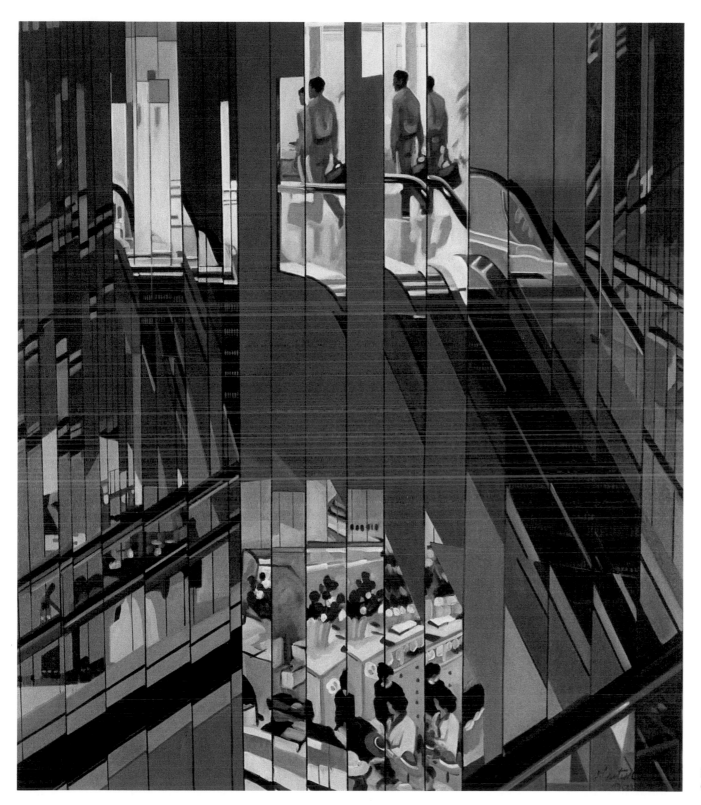

ESCALATION II, 1984
Oil on canvas, 48 x 42 inches 81

The landscape of southeastern Minnesota is so open and flat that you can see across long distances to the horizon line. And above is this immense sky. The movement of the landscape is profoundly horizontal, to my eye; it is about expanse and not ascent. Where the land and the sky meet becomes a point of great tension, visually speaking. On some days, as I look across all that space and all that air to the horizon, I feel that things disappear back there—things become blurred and oddly radiant. Or else, depending on the day, things stand out very cleanly—there's a lot of contrast, as if the sky is resting on the roof of a barn, a tree, the land itself.

What first captures my eye when I study the landscape here is the architecture. You have these enormous expanses of ground and sky, and what anchors it, to my eye, are the human elements: the barns and houses, the silos, the storage bins. They group together to make a little "village," suggesting community in that vast open space. At the same time, these buildings seem incredibly vulnerable in their human scale.

I often locate the architectural elements in the center of my paintings. This seems to maximize the volumes of space around them—the emptiness—and I realize that that's a large part of what I'm painting. I'm not only interested in the things themselves but in their relation to the rest of the painting. Sometimes I feel as if I'm painting a huge container of space in which the human elements exist.

Another result of placing the architectural elements in the center of the painting is a composition that seems classically balanced, static. My hope is that this compositional choice creates a quality of stillness in the work. A painting with dynamic compositional structure pulls you around as you track the artist's manipulation of space; reading such a painting is a very active experience. I want viewers to feel slowed down as they look at my work, to feel addressed by the painting, to feel invited to enter its stillness.

An important part of my painting process is to take long drives. We have endless miles of back roads in southeastern Minnesota: big highways that feed into little highways, that feed into county roads, then dirt roads: there's a real hierarchy. You can go and go for hours, just driving and looking. I'm lucky because I have a good inner sense of direction, or I'd never get home.

Driving and looking as I do when I'm out looking for a site to paint gives me a different idea of travel. I've discovered that you can go five miles from where you live and see all kinds of things if you look carefully. Slowing down, noticing things, getting into the details: that's the pleasure of travel, and I've had that pleasure without ever leaving Rice County.

Different seasons have different attractions for me. In late fall, winter, and early spring, I like the way that you can see the structure of trees; they're completely different then, more like script than shapes. In fall, the air has a golden quality—maybe it's the pollen, I don't know—but it is rich and weighty, and seasons everything you look at with this deep, almost elegiac light. The light of a Minnesota summer, on the other hand, is harsh, unforgiving. It pours down evenly and hits everything with the same unyielding intensity. In this part of Minnesota, the summer sunsets are amazing; the earth and the whole sky become overwhelmed by this yellow light, and long raking shadows deepen across the landscape. Everything acquires those shadows—trees, buildings, silos—all take on a monumental quality from that brilliant backlighting.

I like the beginnings and the tail ends of seasons best, when things are in transition—when it's neither winter nor spring, summer nor fall, but a time of year that we don't have a name for. I'm also drawn to times of day that can't easily be defined—not dawn, not morning, but that stretch of time in between. It's the ineffable quality of such times that attracts me, the fact that they exist outside of our language. And yet, we all recognize that transient light, right after the sun goes down or right before the sky sharpens into the vivid brightness of morning. That ineffable quality, that sense that a landscape is poised on something, challenges me—perhaps because I prefer the ephemeral, the allusive rather than the given. The fleeting, undefinable moment to me seems to get at the truth of things.

Joseph Byrne
Northfield, Minnesota

MIDSUMMER RAIN #3, 1992, Oil on canvas, 21 x 23 inches

I've been painting in this place called the Middle West for twenty-seven years. I spent a year in Los Angeles and another north of San Francisco, and although I have worked in both places, and in particular had a great affection for the Napa Valley, they did not engage me, did not resonate deep inside me as do the space and light of the Middle West. I suppose in many ways it has to do with a Calvinistic sense of modesty, with not being too carried away with the romance of the mind. What is curious is that I've always been most attracted to the prosaic. The less grand, the more engaging it is to me, the more it stirs my imagination. It is all tied together by memory and how the patina of memory works on invention. In the end it comes down to the advantage of living and working in the middle of the country. You are left alone to go your own way. You can get a lot of work done when you are free of the pressures of cultural hipness and fretting over the right career moves. This place gives me time to consider metaphor, geography and autobiography.

There is a wonderful quote from Ross MacDonald that goes, "In the end I possess my birthplace and am possessed by its language." I believe that statement serves painters well. I have come to feel that there is no one season that is better than another, that each time of the year engages me with equal excitement. Deep winter carries as much visual weight and respect as does deep summer. I do not put so much value on time of year; it is the vision that counts and how it is absorbed by the mystery of form, perception and expression.

I interact by being here, by opening my eyes and heart to what is around me. I bike, help my wife in the garden, lie on my back at the edge of a corn field, walk the dry creek beds in winter, sit at dusk listening for the sounds of trains, owls, barking dogs, the vague static of tractor radios and the aroma of food cooking on the evening air.

Keith Jacobshagen
Lincoln, Nebraska

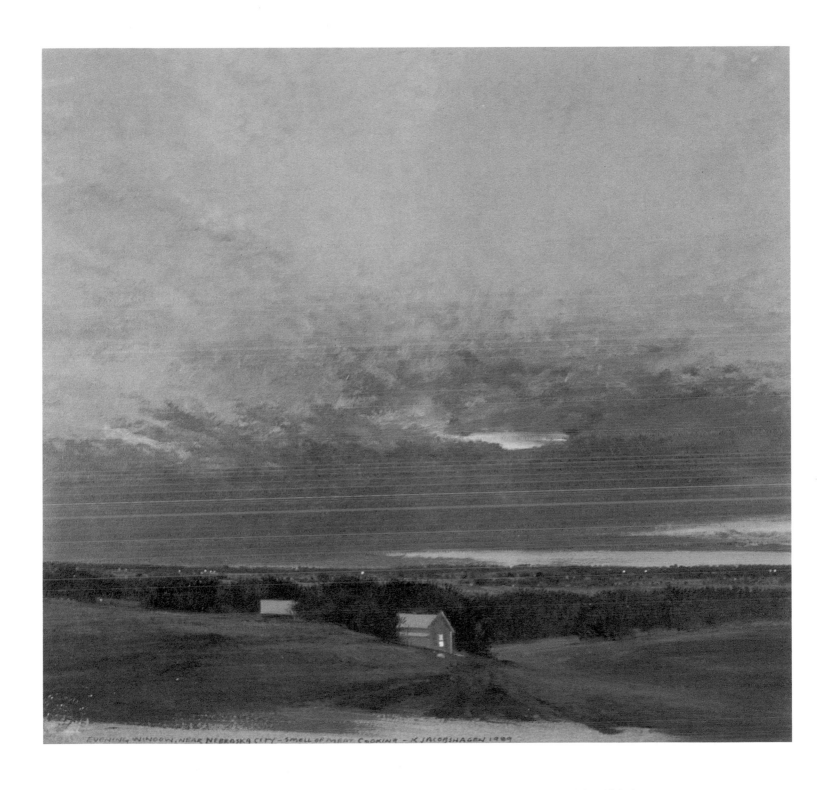

EVENING WINDOW NEAR NEBRASKA CITY–SMELL OF MEAT COOKING, 1989, Oil on paper, 11 x 12 inches
Photograph courtesy of Babcock Galleries, New York

Many years ago I decided I would live anywhere in order to work. Many artists try to do just that. That means artists make their environment, i.e., studio, conducive to their work. What is outside that studio is another concern, and that is where the influence from the neighborhood, town or city pervades the work, whether it is covertly or overtly. We adapt to that outside environment. I am a native to Texas. My work gives expression to my being not only a native in place but also culturally as well. My work has dealt with many issues that reflect who I am, such as being a Chicano (a hybrid of two cultures), being brought up a Catholic (which I am not anymore, but its influences are still reverberating), being a Texan, and also my relation to the world. Houston, Texas, really has only three seasons: summer—hot and humid; winter—cold and sometimes freezing fall/spring—cool and comfortable. I look forward to October, when the weather cools. But it is harder to work when the weather is finally nice....I walk around the neighborhood, since I live and work in a storefront next to a good cafe, across the street from a convenience store and a burger place and a twenty-four-hour restaurant. I ride my bicycle for exercise...since I do not have a yard, I sometimes sit on my step outside my door and work on my truck, which is parked parallel to the street. And I have two large windows through which I can view the outside world. Some of my artwork is about the environment and what we, the human race, are doing to it. I often use the image of the crucifixion in which we crucify the world. The heart is our world and the world is our heart. What we do to the earth we do unto ourselves.

Benito Huerta
Houston, Texas

DIVAS, DESTRUCTION & DEPRAVITY, 1992, Mixed media, 35 x 55 inches
Photograph: Hickey-Robertson

When I left Texas and went up to the University of Michigan, I found myself with "x" number of months and no sight of green. Everything was all white and snowy. That's when I started reminiscing, thinking back. I started looking at photographs I had taken, and they affected me. Since 1988, in Texas, as I looked at nature day to day, it made me think about Zen, As I read Zen, it made me think more about "beingness," being wind or being a tree or air. These thoughts entered my work. I am Western. Those ideas become more romantic; those words become more appealing.

I think by having nature in front of me day to day, inviting it, my art changed. You can live in it and not see it, but nature is also a state of mind, where you can live it, you can invite nature to come into your life. When that is happening, when you are aware of nature day to day, it becomes easier to go into the studio, close the door and paint how you are affected by it rather than paint the appearances of nature. That is when the tree I have been looking at becomes another type of tree. I am very intuitive about my color. I don't have to worry about color; I do worry more about composition. The important thing for me is to let things happen as images evolve on the canvas.

In all my travels, I never felt in my element. It really bothered me, until I came here to Corpus Christi. Culturally, we are seriously deprived. It is bad culturally, but the one thing that has always grabbed me here is the nature. The power is in the soil. I love to have water around, but I think it is the energy in the soil—the trees and the plants and the flowers—that really sparks my excitement. The sky and water become added flavors and colors and forms. Together they all become what I need to make a painting.

Bruno Andrade
Corpus Christi, Texas

KIND OF MAGIC, 1992
Oil on canvas, 72 x 60 inches

I find myself caring for two places, one being my residence in Corpus Christi, Texas, and the other my parents' home in Hemphill, Texas. Corpus Christi offers me a wonderful sense of light, which affects my color. The coastal light, with its change of color from dawn to dusk, excites intense feelings. I find that my emotions are stirred as the light and time change. Hemphill is located in East Texas and has a different nature. Its trees and hills evoke a mystical sense of life. Both areas give me a oneness with nature which makes me happy to be alive. It is this oneness that I am currently trying to paint.

My relationship with nature involves hiking through terrain such as sand dunes and thick woods, walking my dogs, taking care of my fish pond, sitting outside at night listening to nature, and mostly fishing during the night. I also like to interact with nature in ways like swimming, planting flowers, vegetables and trees and taking care of the yards. Summing up my involvement with these two environments, I would say Nature talks and I try to listen.

Michael Ambrose Lathrop
Corpus Christi, Texas

WHEN TWO BECOME ONE, 1991
Oil on canvas, 66 x 50 inches

As a native American of the Hopi-Tewa tribe we are located in the north central part of Arizona. Art is not separate from our lives. It is always a part of us, from the ancient petroglyphs and pictographs of our ancestors to the art which is produced today in the twentieth century.

The mountains, clouds, sun, moon, animal and plant life are an integral part of our lives and relate to our environment through forms of meditation, sound, motion and color, telling a very important story of the coexistence of man and nature and his environment. Many times these are depicted through ceremonial dances.

Dan Namingha
Santa Fe, New Mexico

HOPI CEREMONIAL DANCE, 1992, Mixed media on paper, 30 x 40 inches

Ever the contrarian…I often think that, for me, growing up on the East Coast, it was the otherness, the unfamiliarity of the Western landscape which led to my long-term interest and involvement with it. I'll never forget the impression it first made on me when I arrived by plane in Wyoming, where I was to work on a ranch that summer—the wide open spaces, big sky, red earth and mountains—so different from the green, close, muggy landscape of New Jersey. Indeed, I have come to know the West quite well and think of it as home, yet something of that freshness remains. When you know a place well it gets inside you and enters your art quietly and naturally without your awareness. I know the light, the skies, the hills, grasses, trees and cows of northern California so well, they are what I now think of as skies, hills, etc. They are my skies and hills, like my face is my own. We can't see our own faces directly. So the sense of place in my paintings is best perceived by others.

In terms of actually working on a painting, I now have a landscape vocabulary which I learned at the feet of local hills. These things I can paint from memory, which gives me a flexibility in composing, the freedom to change a real scene, or simply make one up. Also, knowing one set of natural forms intimately gives you an insight and understanding of many other "cousin forms," perhaps even of form itself, those elements and harmonies which exist in all things. From an intimate knowledge of the particular springs an intimation of the unusual. That particular sea, that sky, because they are just themselves, perfectly, become complete, become all seas and skies. When a painting rings true in this way it gives us a sense of timelessness.

Willard Dixon
San Rafael, California

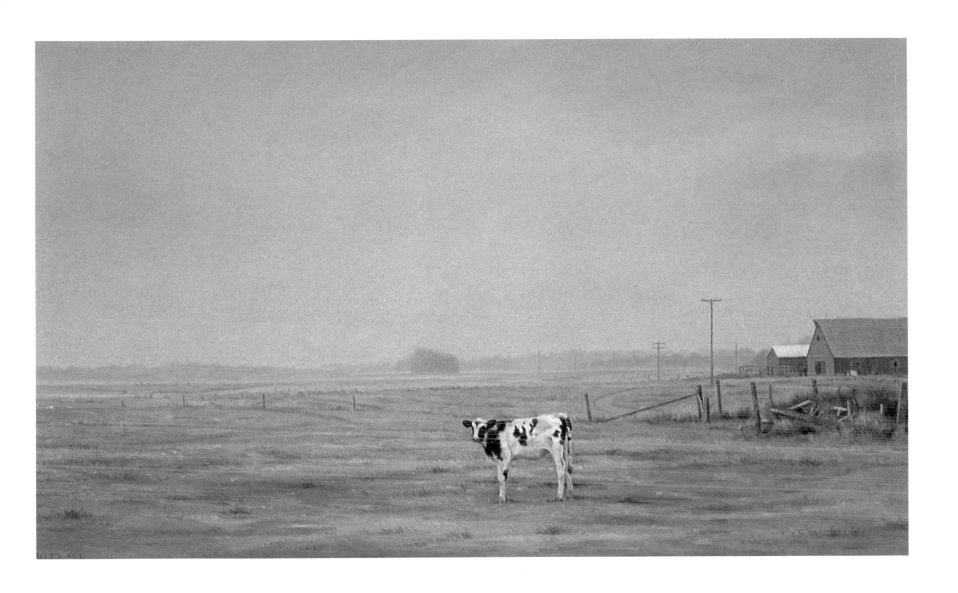

GROUND FOG, 1991, Oil on canvas, 36 x 60 inches
Photograph courtesy of Fischbach Gallery, New York

Not a day goes by that I don't take a hike. For me it is like eating or breathing. If it is raining, I quite often will head for the mountain trails, with their woods and rushing streams. I love the sound of the rain in the forest. Wind and rain—I head for the ridge or the edge of the cliff to feel the full impact of the storm.

And when I hike, I paint. The "painting" might never end up on a canvas, but if all the variables coalesce at just the right moment, cinched with the vantage point that draws me, then there's a good chance it will.

Sometimes I'll take a sketch pad—sometimes a camera or a canvas. sometimes I'll bring a bag along for mushrooms. In the blazing sunlight on a day after a big rain there's a good chance there'll be golden chanterelle to pick and almost always the soft stare of the deer.

I look for places with bone and power, places where the convulsions of the earthquakes show through—mighty fists and windswept valleys that rush down to the sea.

In the mornings I work my garden. I dig and watch the clouds move across the sky. Gardening is part of my existence from my early days growing up on the farm. You planted and ate what you planted, The cycle was simple and clear. And the earth was warm under your bare feet.

The light on this piece of coast is like and not like the light in northern Wisconsin where I was born. The power of the sun on the Pacific strikes a resonance so intense that it blinds everything in its path. and there's a battle there—a battle between earth and sea and sky—a cauldron of light and air and massive shapes that appear and disappear in the fog.

In the intense green of late winter/early spring the Monarchs come down from the mountains. They float and glide and settle on the tall spires of the "Pride of Madeira." If you're walking down the hill to town or down a muddy road on the Mesa you can see hundreds of them clustered on the eucalyptus trees.

What's really fantastic is to have a car pass you, which frightens the butterflies into instant flight, off the trees and into the sky. Until that moment, though, the trees quiver with hundreds of moving wings.

I paint to carve a reality out of this reality. I paint in order to feel the fog move across the land, to smell the tall dry grass in the valley in all its yellowness. I want the canvas to speak to me about struggle and beauty and the ecstasy that sings in the wind.

You know you've arrived in Bolinas when you get to know the dogs; not to mention the cats, the deer, the possums, skunks, raccoons, snails, seals, foxes, the pelicans (Oh! the pelicans) and the cougars (I've seen them in the hills, slinking over the edge down into a ravine, or standing firm with their cubs).

7:30 A.M.
A car swings around the corner on Wharf Road and drives past the bar, the wheels picking up the water that Barbie, Mary's daughter, has just thrown from a bucket out into the street. Across the street an old Volkswagen bus lists at the curb. A still black dog, as if carved at the entrance to an Egyptian tomb, lies, head up. And the morning light comes in from the sea. As the day progresses it slowly works its way down the street.

Judy Molyneux
Bolinas, California

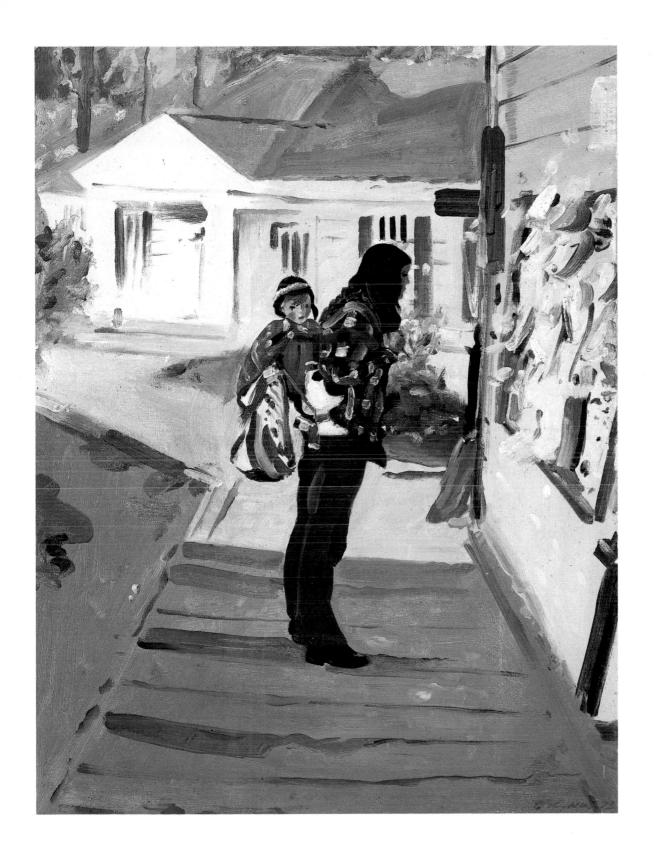

READING THE BULLETIN BOARD, 1973
Oil on canvas, 32 x 25 inches

I don't know if it makes sense for me to talk of different places being more or less "conducive" to the making of my work—it makes the place sound as though it were a mere facilitator to a process that had nothing, or almost nothing, to do with it, as certain atmospheric conditions will help a car engine run better.

What is it about a particular place that makes me want to make an image? It can be many things, but perhaps one near-constant is a sense of personal happiness in the presence of the thing I am painting, along with its being able to evoke something of my sense of life at the time.

The kind of happiness or sense of life I am talking about doesn't have much to do with the identity of the places or things I paint—my paintings aren't commemorative in that sense (if I had a coat I particularly liked, I wouldn't necessarily have any impulse to paint it just because I liked it—I would have to like how I felt while looking at it). I've drawn images both from places I'm extremely familiar with and from places I've just visited or passed through.

When I talk about being happy in the presence of a thing I'm painting, that can take in a fairly wide range of response. Last year I completed a very large (7' x 10') painting of a children's park that's beautiful in a way that's quite obvious and that anyone would expect to take pleasure from. But it felt exciting to me in a *personal* way as well; I had (maybe because I don't go there often and had just stumbled upon it) a sense of private discovery about it, of secret possession, as though it gave me vicarious access to a world I couldn't quite have. And the view was moving to me in its complexity and expansiveness as well as in its serenity, its domestic and sheltered quality.

Sometime before the children's park, I made a small painting of my studio—there's an armchair, a jacket on it, a shaded window and an exhaust fan. The shaded window makes for a kind of milky light, and it's not a scene of obvious interest...it's something I don't usually pay attention to when I go to the studio to work. By turning my attention to something I normally saw with the corner of the eye, I hoped to get at an emotional substratum of my life, the level of feeling that underlies a time in your life and that can be forcefully evoked later by a piece of music or a smell.

So even if the ostensible subject isn't happy (it evokes for me a hopelessly dull afternoon), if the painting conveys some heightened sense of being, there's something happy in it for me.

I don't know that I'm as native to San Francisco as someone who was born here, but it feels like home to me. When I first moved here (about nine years ago), I was aware of this place not having the richness of association that L.A. (where I mostly grew up) had for me —despite how beautiful it was here. Things didn't have a subtext. A lot of San Francisco looked merely picturesque to me.

I think that a sense of feeling at home is part of the implicit subject of some of my paintings.

I like winter, for the clarity of the light—for the many clear, unhazy days. I enjoy the sun low in the sky, the chillier weather, the sense of the indoors as a refuge from the chill and from the shortness of the day.

In spring there's about six weeks when all the countryside around San Francisco gets green—it's spectacular, like an infinite park. Maybe it's supposed to last longer, but my stay here has pretty much coincided with the drought. I'm very fond of the dairyland north of the Golden Gate Bridge—I like it particularly in spring.

I like fall for its sense of going into a minor key and late spring for the growing sense of opening up.

In the summer here I like the long days.

Practically all I do to physically interact with the environment is to go to the supermarket, take an occasional walk, and drive out to paint.

Peter Nye
San Francisco, California

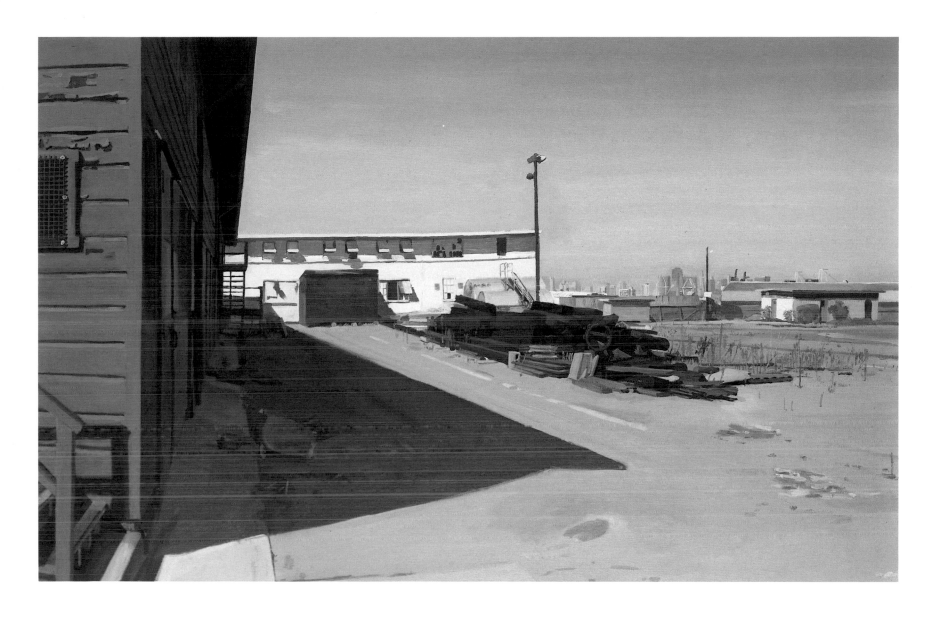

GREEN BUILDING WITH LUMBER PILE, 1991. Oil on canvas, 34 x 54 inches
Courtesy of Contemporary Realist Gallery, San Francisco; photograph: John Wilson White

99

When does a person become a native? Certainly a good way to know what a place is like is to work there. My work is painting. If I now feel native to Oakland, it has come about largely through the activity of painting. My painting subjects come from day-to-day experiences—the ordinariness of the city streets, the people I see every day and, in the series, sculling, an activity I've been involved with for several years.

Rowing as a subject for painting has a distinguished history in the United States, largely through the work of Thomas Eakins, whose paintings I have greatly admired. During the early 1970s, when my wife and I lived in New York, we traveled to Philadelphia several times for the sole purpose of seeing that museum's collection of Eakins's paintings. The first time we went there, after spending several hours at the museum we walked down to the banks of the Schuylkill River, where rowing clubs and scullers still hold forth. Having just seen Eakins's paintings, this seemingly eternal landscape made a deep impression on me.

Many years later, we moved to Oakland, California, a city graced with a large lake in the middle of town, just a few blocks from my studio. I used to jog around the lake and noticed, to my surprise, scullers on the lake. I had no idea this historic activity took place in my adopted home city in the West. I discovered that the lake was home to the Lake Merritt Rowing Club and inquired at their boathouse located on the lake's western shore. I learned that the LMRC had a program for neophytes. I joined the club and started sculling as a beginner, in a wherry tied by rope to the dock where my teacher stood, hollering encouragement and rowing tips. Eventually I was able to take out a single scull, and I have been sculling now for about four years.

Since then I have done a number of paintings on the subject. This particular painting is one of that ongoing series. It depicts early morning practice, the coach's launch going from boat to boat instructing the rowers.

Joseph Oddo
Oakland, California

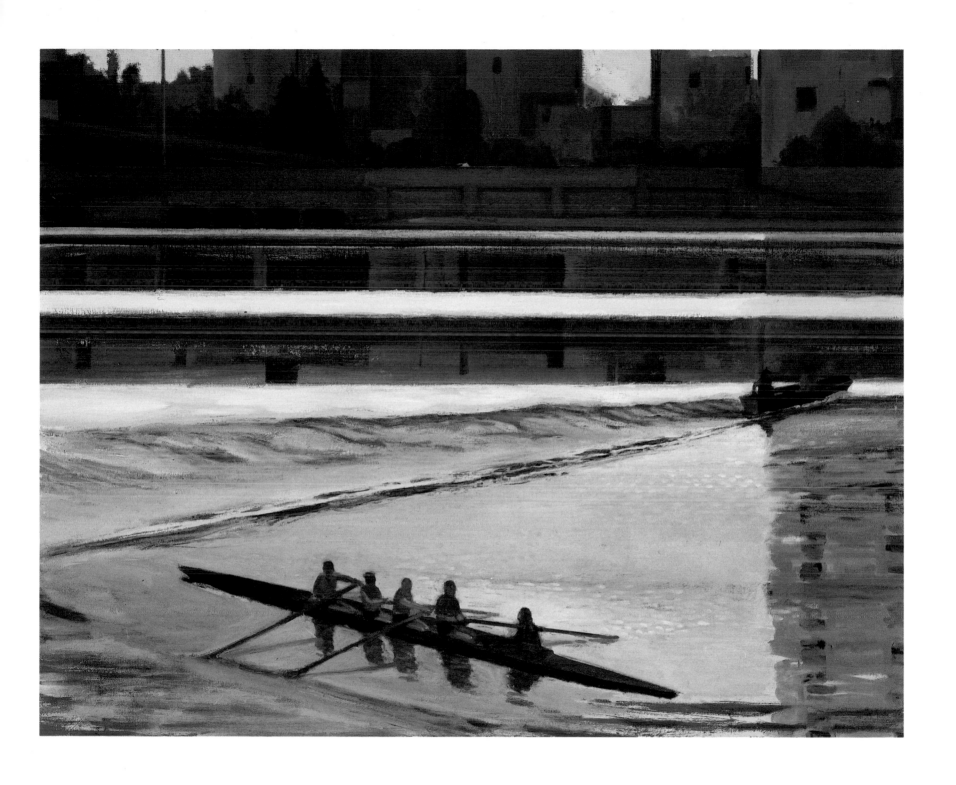

FOUR WITH COXSWAIN AND COACHING LAUNCH, 1990–91, Oil on canvas, 40 x 56 inches
Photograph: Lee Fatheree

Certain places seem best suited to manifest the quality of light on a given day. For me, finding the spot that embodies the light of a particular moment is what outdoor painting is all about. Over the last seventeen years, painting a small stretch of California coast I have come to think of as my home, I have begun to believe that light and atmosphere are perhaps more vital to our sense of place than the physical characteristics of the land. Conditions of light engender a scene with wholly different color ranges which, in turn, strike different emotional chords, evoking a variety of moods. Squat, brutal headlands in morning shade may become golden buttresses reaching heavenward by the glow of the setting sun. The fiery color of rocks in morning sun can yield to velvet earth tones under an overcast sky. The face of the land seems a stage where light and atmosphere play out their drama. When you add to this that the land itself is subject to constant change, from seasonal variance to the cataclysmic, the possibilities are limitless. Someone passing through can only experience one of these impressions. To the native goes the privilege of knowing the variety.

Over the years, I have learned to anticipate conditions: what the direction and angle of the light might be, how the tide might affect vantage points, or when and where the fog might come into play. This knowledge helps narrow the choices of where to look for that special spot for the day. But mostly I rely on an intuitive sense that has been with me since the day I moved here. This sense has proven quite consistent in leading me to the right place, at the right time. It is this sense that makes me know I have become a native.

Peter M. Loftus
Santa Cruz, California

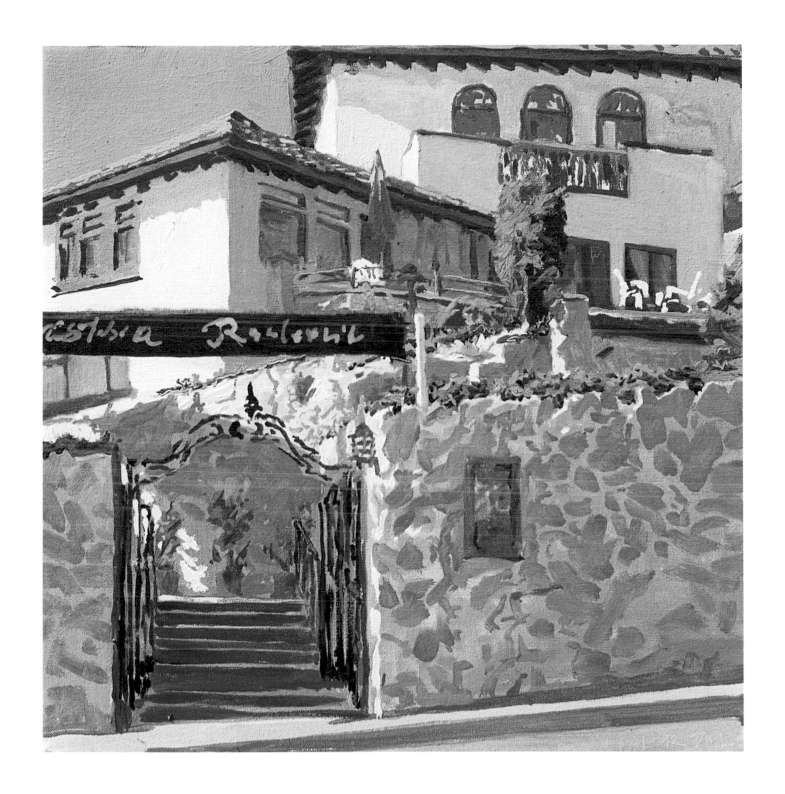

CASABLANCA, NEW YEAR'S DAY, 1992, Oil on canvas, 16 x 16 inches

Place for me means an area I have lived in and been moved by enough to paint it many times over, enough so that when I close my eyes, I have its image, its particular sense of space and light very present in my mind, both visually and physically. It is a place I want to be in and sense the air, smells, sounds and animals. A place that has become part of my consciousness and makes me feel a particular way physically. What makes a place "right" for me is a combination of familiarity and exaltation and/or peace. I walk a lot, every day, and my observations and personal reflections become inextricably woven with those places. I tend to pick a few places and go back to those same places over and over, day after day, to walk and to paint (like Cezanne), building up many layers of associations. I tend to choose places with large, panoramic, unobstructed views, without development, houses or people. I also frequently collect bits of a place as momentos and savor them as a meal. I feel these places are as necessary for me as food.

Marjorie Portnow
Santa Cruz, California

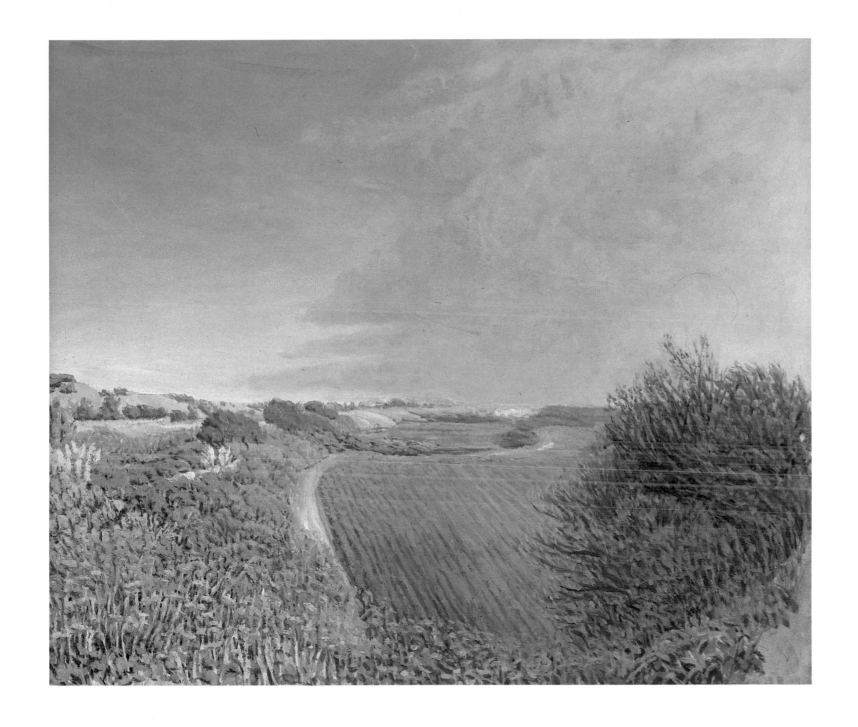

HALF SUN, HALF FOG, WILDER RANCH, SANTA CRUZ, 1992, Oil on board, 14 x 16 inches

What makes an environment conducive to my creativity? A combination of unexpected visual stimulus and the familiar recognition which comes from daily experience. It seems that I have always preferred places which encompass dualities, the clash of civilization with the wildness of nature, both in play upon the landscape.

Since my childhood, I have loved to live near the ocean, and presently get great comfort and strength living and working on this peninsula surrounded by the Pacific Ocean and the Los Angeles Harbor. This place is named San Pedro, for Saint Peter who watches over the gate to the Angeles. Early explorers first named the bay "La Bahia de las Fumas," for the many smokes rising from the native fires. Recently I have come to respect the ocean as a great source of energy and power for me. Although I do not consciously include it as imagery, my paintings are permeated with its rhythms, undulations and shifting atmospheres.

It is important that I be able to have physical contact with the landscape in which I live. So walking to the studio is a beloved activity which I use to get in touch with my sensibilities and clarify my energy. This is time to take in the true sense of place through grand vistas as well as intimate detail. From the steps of my studio I can see through the eucalyptus to the many smoke plumes which ring the bay, only today these smokes are from the many oil refineries.

I would consider myself native to the California coastal regions, having also lived for a considerable time in San Francisco and the city of Eureka, which is on the Humboldt Bay. Although the secrets of each place reveal themselves in time, it has taken nearly three years for me to be able to truly recognize and empathize with this region's special qualities.

My work attempts to speak about contrasts which I find particularly striking in this region. Southern California is a proverbial Garden of Eden, complete with exotic plants, trees and flowers which take turn blooming twelve months a year. These gardens and lawns, however beautiful, have been cultivated with borrowed water in order to transform this desert region into user-friendly suburban neighborhoods. However, the vast concrete sprawl which lies beyond every yard, which connects every city, reveals a completely industrialized basin, complete with a concrete-lined river.

Being native means being aware of and in some way responsible for these contradictions. My work reflects this dichotomy, tries to make sense of it by attempting to make it whole. Being native also means participating with joy and wonder in a particular life-style, which easily merges inside and outside, where changes are subtle but enticing and the ocean and the sun are always constant companions.

With joyful anticipation, I wait for the rains to come wash the dust and desert air away. The rainy season is winter and early spring. By March, all is emerald and renewed. Plants bloom with abundance and there is often what we call "weather"—clouds, winds, storms, etc. At this time even northern flowers such as purple lupine can be found alongside the caca lilies and bright yellow mustard plants. Treasures wash up on the beach, sometimes homes slide into the canyons and generally all is in flux. Late spring, the great jacaranda trees bloom completely lavender, lining many streets with riotous color. The ice plants cover many expanses with magenta and pink, and the luxurious coral trees bring forth gigantic orange and indigo flowers.

Then steady static summer sets in with its torrid sun. All seems flat, blank, unmoving. The hot blue sky does not change again until November. Summer's one pleasure is the ocean fog which crawls over the coast, appearing at times like a winter blizzard. Summer blooms are countless, among which the bougainvillea and the oleander are the most beautiful. Wild Mexican parrots nest in the palms and flocks of pelicans fly in formation in the skies. The bay is active with commerce and beach-goers.

Early autumn in southern California has none of the energy and drama which someone raised in New England would expect. In fact, it is the hardest season to appreciate. A condition called Santa Ana sends oven-hot winds west from inland deserts. This is usually accompanied by very unhealthful air quality and distinctive orange and brown stripes in the sky. However, if one looks carefully, some of the live oaks have turned gold and there are red eucalyptus leaves on the sidewalk and the giant sunflowers have withered on their stalks. Pumpkins arrive, the night comes early and soon the winter rains follow.

By moving through space, all my senses are activated and I begin each day to know each day—to comprehend specific times in space. I like to cover terrain by foot, to walk vigorously and to feel my whole body breathe. My studio is on the hill in a compound of renovated WWI army barracks. I have been gardening the area near my building for three years, but the soil is like silt and the ocean winds discourage growth. But there is always color from nasturtiums, roses and morning glories. I collect many specimens, including insects, dead birds, branches, stones, shells, root systems and various nameless fragments of all sorts.

Marie Thibeault
San Pedro, California

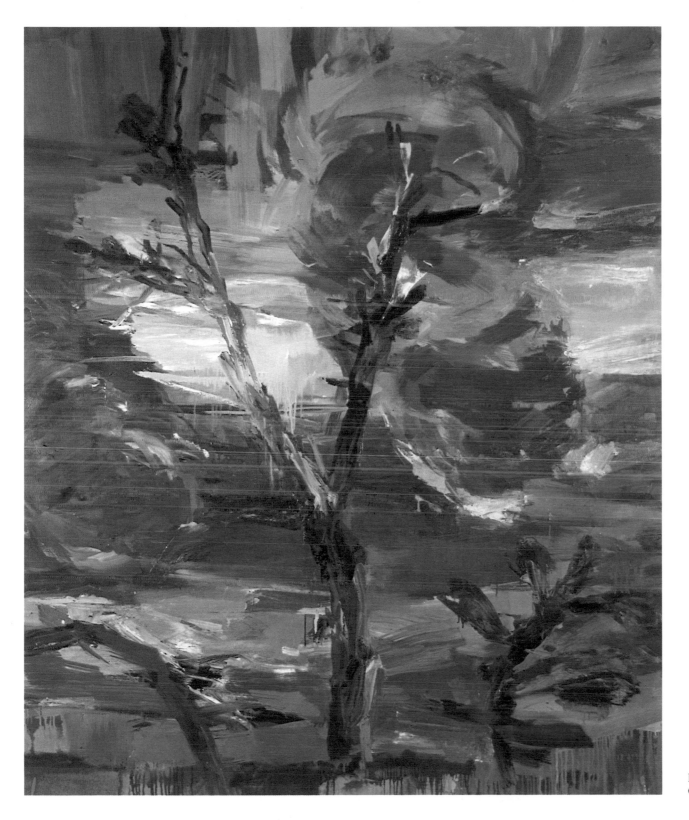

BLUE FIRE, 1992
Oil on canvas, 72 x 60 inches

The quality of light in a particular environment has always affected my work. In Los Angeles, forms merge in the distance—whether from fog, smog, brilliant reflection or glare—and this kind of light is evidenced in my work. I'm always concerned about the kind of light the painting is viewed under. The experience of the image depends on it.

I've lived in Venice Beach, California for five years now, and it definitely feels like home. I know the people who live in the neighborhood, as well as the pharmacist, my local grocer and the postman. I feel connected to my life, and my work expresses this relatedness.

All contrast to the everyday heightens perception. In an urban area where nature is experienced in glimpses, the change of seasons increases our awareness of the environment.

I recently purchased a beach bike, and have been taking afternoon breaks from my work in the studio, for rides along the oceanfront.

Mary Koneff
Venice, California

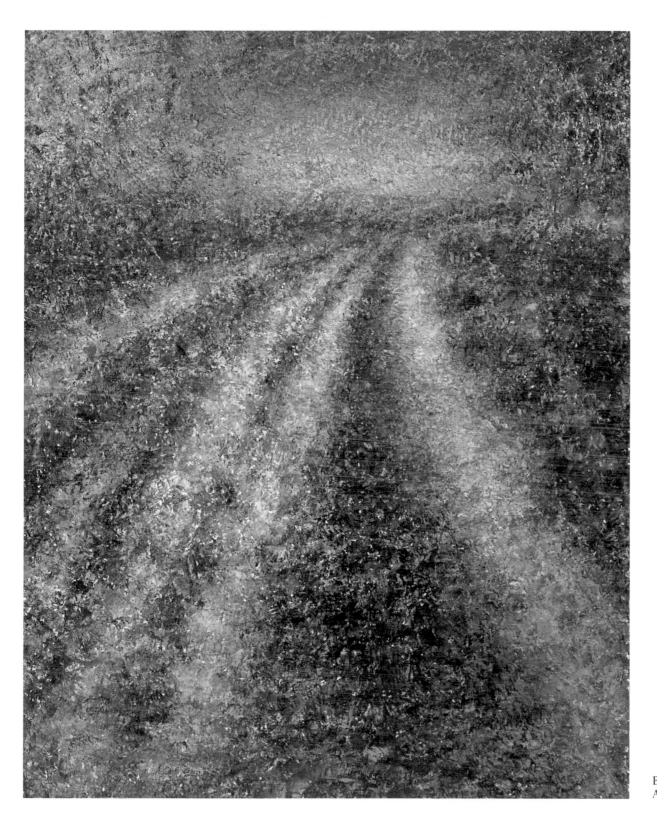

BROKEN LAND, 1991
Acrylic on wood, 60 x 48 inches 109

I was born in Georgia; my family was born there; my childhood was there. There for the first time I breathed air, my first weather, the bone-crushing familiarity of humidity and heat and night sounds. It was my native tongue.

I have lived on this island in Washington fifteen years. Other places still cut me with longing/memory/home. Yet it is this place that has claimed me: when I am here, I am me. I learn it like a second language, with idiosyncratic pronunciations and mixed-up words.

I paint indoors, at home, in my room, in the right half of the room. The window is here, the door is there, I am here.... Our house is small and wooden, in a clearing. When it rains, the sound is always on the roof. In the summer, dragonflies deepen the air. At night, the outside darkness seeps through the windows and pools up—the walls slow down but do not stop what is out from coming in.

I particularly respond to fall and winter. The air infiltrated with water: fog, cool humidity, rain, snow. Boundaries become permeable. Sodden and brittle, red and grey. The huge sound of tiny tree frogs. The ground sloshing with water, the garden drowned.

I most directly physically interact with my place by gardening. My gardening is humble and ignorant. I'm still touched when a perennial reappears, as though it likes me! But largely I do not nurture plants: I garden by motion and elimination. I hack and weed and rip out and clip and move rocks, shove dirt, dig, edit. I squat close to the dirt. I forget to look at the plants—I just want to be close to the dirt. Perhaps I am then open to the collective unconscious of the plants, the insects, birds, earth. I can absorb it, almost like something rising up from the ground.

My painting is fed in this indirect way—through absorption, immersion, the slow drip of familiarity. Scenery is for the eyes, and I do not exactly paint with my eyes, but rather on the border of sight and touch, the border of...At one point I decided that I did not like to scrutinize nature, looking for a pleasing aspect, a dramatic juxtaposition, a freeze frame. I felt I was using her; it was an uneasy relationship.

Now I assume that I absorb, that I cannot help absorbing, that my place inhabits me as much as I inhabit it. I am drenched with deeply percolating water. I paint from within, and what I find within is where I am native.

Dana Roberts
San Juan Islands, Washington

THE LOST SISTER, 1992, Oil on canvas, 38 x 36 inches

My physical setting is essential to my painting. This place is my essence. I was born here. As far as I know, my most distant ancestors lived here. This place has mountains, rivers, hills, streams and oceans. Birds sing into the air and fish flash in the water. This place grew me so I could see her and tell her how beautiful she had become. When young she needed no one to tell her. She cavorted with the sun and created her forms. But as she grows older she needs affirmation of her splendor. I am one in a line of admirers that she made to paint for her. We do not hold up a mirror so she can admire her forms; rather we gaze and sense her complex and vast creations in awe, and from that inspiration we fashion simple forms with primitive tools for her pleasure and delight.

Joe Miller
San Juan Island, Washington

SCREECH OWL, Oil on canvas, 37 x 38½ inches

The contemporary local Hawaiian imagery has been the predominant focus of these past twenty years of painting. I have gone through many "series" of subjects: Chinatown Food series—at that time there were many evictions in old Chinatown in an effort to upgrade/revitalize that area; Kodak Hula Show/tourist series—comment on the commercialization of Hawaii; Fish Auction series—the old fish auctions in Chinatown, which contributed vivid local color to an area that is no longer there; Fish Study/Water series—involving the pristine coastlines of the Big Island/Molokai, which in some areas are already developed with upscale hotels. I have lived in the islands all of my life.

I feel the artist is merely a reflection of his time/environment. I generally anticipate the seasons from the point of view of the waterman. Fishing, e.g., summer high season for oama (baby goat fish) to come close to shore; papio and ulna follow; tapering off in fall—winter fishing is slow; spring is the annual Molokai fishing tournament. I actually enjoy and have surfed longer than anything I've done, so when the surf is up I'm in the water at dawn, before light. I used to paddle/compete canoe. Presently: organic gardening and composting, growing vegetables, yoga and meditation, surfing, some fishing, raising a family, swimming—though painting keeps me indoors the majority of the time.

Doug Young
Honolulu, Hawaii

JIMMY'S KAGAMI: FISH STUDY #7, 1990, Watercolor, 40½ x 60 inches

Artists' Biographies

Conventional practice has husbands and wives collaborating in producing children; much rarer is the collaboration of **Doug and Judy Alderfer-Abbott**. They join in the production of paintings! Doug went to the Pennsylvania Academy of Fine Arts in Philadelphia. Judy completed her studies at the Philadelphia College of Art. Since their meeting they have indeed painted together, on the same canvas, going so far as to describe shows of paintings produced by this method as "solo exhibitions." There have been eleven such displays, several at the Staempfli Gallery in New York.

Thirty-eight year old **Candida Alvarez**, a graduate of Fordham University, has lived most of her life in New York City. Since 1980, she has had eight solo exhibitions of her paintings, including a show at the Bronx Museum of Art. A recent *ARTnews* feature carried the headline, "Candida Alvarez: Myth, Memory and Old Lace." Alvarez is represented by June Kelly Gallery in New York.

Bruno Andrade's extraordinary sense of color allows him to create evocative landscapes with a deep south Texas accent. Since 1978, Andrade has shown in a dozen solo exhibitions and forty-six group shows, His work is in the McAllen International Museum in Texas, the Mexican Museum in San Francisco and the Museum of Contemporary Hispanic Art in New York. Forty-six year old Andrade has twice been awarded NEA Fellowship Grants. He is a professor of art at Corpus Christi State University. Andrade is represented by Lynn Goode Gallery in Houston.

Nell Blaine is the doyenne of American landscape painting. Year after year, showing no sign of diminished energy, Blaine continues to produce light-filled paintings of places and flowers. Her exhibition record is intimidating, beginning in 1945 at the Jane Street Gallery in New York, and continuing with museum and gallery shows all over the nation. Her paintings are in the permanent collections of, to name only a few, the Metropolitan Museum of Art in New York, Hirshhorn in Washington, D.C., and Virginia Museum of Fine Arts, Richmond. Blaine's work was often seen at New York's Poindexter Gallery. She is now represented by the Fischbach Gallery in New York.

Richard Bogart has had long-time exhibiting relationships with the Poindexter, J. P. Natkin and Douglas Drake galleries in New York. His misty, shimmering landscape paintings have been included in a number of group shows, including "A Sense of Place: The Artist and the American Land", at the Joslyn and Sheldon Memorial Art Gallery in Nebraska. A graduate of the Art Institute of Chicago, Bogart also studied at Black Mountain College in North Carolina.

A magna cum laude graduate in Art History from Princeton University, **Bill Botzow** leads a hybrid life, producing his own art works, collaborating on projects and installations with an ecological focus, and participating in a range of community activities including the Vermont Council on the Arts where he now serves as chair of Planning and Policy Committee. The Five Points Gallery in East Chatham, New York, recently featured his work.

Joseph Byrne brings fresh eyes to the old-school notion of direct landscape painting. He took advanced degrees in painting at the University of Iowa, before returning to his home state of Minnesota. Byrne has been a resident fellow at the Vermont Studio Center and has had a MacDowell Colony fellowship. Since 1986, Byrne has been teaching art at Carleton College in Northfield, Minnesota.

Born in Havana, Cuba, **Orlando Cabanas** has shared his work with audiences in Mexico, the Dominican Republic and Spain, as well as in Florida where he has lived for many years. A frequent exhibitor in the local Latino community, fifty-nine year old Cabanas is currently represented by the Caroline Art Gallery in Coral Gables.

Jim Cantrell is deeply Mid-western. Born in Oklahoma, he took degrees from Penn State, the University of Northern Colorado and the University of Nebraska. For many years, Cantrell was largely known for his pots, though he painted all the while. He and his wife, Jeanette, came to Bardstown, Kentucky, twenty-two years ago, enlivening the cultural life of a community better known for other matters of the spirit. Cantrell has works in several museums, including the Sheldon Memorial Art

Gallery in Lincoln, Nebraska, the J. B. Speed Art Museum in Louisville, and the Owensboro Museum of Fine Art in Kentucky.

Whether it be from the tops of tall buildings or precarious ridges in the Hudson River Valley, **Marcia Clark** insists on experiencing her subject matter. Clark's varied life has included stints as Artist-in-Residence in Big Bend National Park in Texas, curator of the six-museum exhibition, "The World Is Round," for which she also wrote the extensive catalog essay, and a featured role in the Nebraska ETV produced film, *A Sense of Place: The Artist and the American Land*. Clark holds degrees from both Yale and SUNY/New Paltz; she has taught for the Metropolitan Museum of Art in New York and for Parsons School of Design. Clark once retraced Thomas Cole's New England journeys, writing about it for the Smithsonian. She has had fifteen solo exhibitions, most recently at Blue Mountain Gallery in New York.

Alan Cote's paintings go beyond nature's appearance and reckon with the ways our senses interact with natural phenomena. Winner of three major awards—a Guggenheim, a CAPS (Creative Artists Public Service grant), and a National Endowment grant, Cote has had more than twenty solo exhibitions. His paintings are included in many public collections including the Museum of Modern Art, Whitney Museum of American Art, and the Guggenheim Museum in New York. Cote's paintings have been seen in shows in Europe and Australia. For many years he has been associated with Washburn Gallery in New York.

David Coughtry holds degrees in painting from the State University of New York at Albany. His work was included in, "The New Response: Contemporary Painters of the Hudson River," organized by the Albany Institute of History and Art in 1985. Coughtry has had a number of commissions and, among other activities, has done sets and construction as well as designing and building a passive solar residence.

Thomas Crotty has the unusual distinction of being both a painter and a gallery director. A one-time lobster fisherman and still an avid sailor,

Crotty runs the prestigious Frost Gully Gallery in Portland, Maine. His lucid, sharply etched paintings of places are included in a number of public collections, including the Farnsworth Museum in Rockland, Maine, and the Portland Museum of Art.

Janet Culbertson is a painter with a mission—use art to arouse our passions about the state of the deteriorating physical environment. Her concerns have been made vivid in over fifteen solo exhibitions and a long list of group shows. Culbertson has written on ecology and feminism for *Heresies* magazine. Her artwork is included in twelve public collections, among them Guild Hall in East Hampton, New York. A recent interview in Woman's Art Journal described Culbertson's artwork as "Political Landscapes."

Willard Dixon's disarmingly realistic paintings have earned him a place in the permanent collections of the Metropolitan Museum of Art in New York and, in California, the San Francisco Museum of Art and the Oakland Museum. A winner of a NEA Fellowship Grant in 1989, Dixon studied at Cornell, the Brooklyn Museum Art School and the San Francisco Arts Institute. For many years he exhibited with William Sawyer Gallery in San Francisco. At present he is represented by both Fischbach Gallery in New York and Contemporary Realist Gallery in San Francisco.

Carol Field is an artist for whom water is not only the staff of life, but the primary source of inspiration. She studied at Pratt, the Art Student's League and William Stanley Hayter's famous print studio, Atelier 17, in Paris. Field lived in Europe for a decade, exhibiting widely in France, Portugal, Belgium, and Italy. In the U.S., she shows with Five Points Gallery in East Chatham, New York, where her most recent work was exhibited as a collaborative effort with Bill Botzow. At the moment, Field is living a bi-coastal life, working in Los Angeles as a set designer for television and film.

Jonathan Green's career has had an amazing trajectory. In ten years his work has been featured in twenty-three solo exhibitions and has been discussed in no less than seventy-five publications. A product of the low country Gullah territory of South

Carolina, thirty-eight year old Green now lives and works in Naples, Florida. He earned a BFA at the School of the Art Institute of Chicago. New York viewing of his work has been arranged by June Kelly Gallery.

Artist, art activist, environmentalist, author, and expert witness on natural and scenic beauty, sixty-two year old **Alan Gussow** leads a truly hybrid life. He has had forty solo exhibitions and his work is included in thirteen museum and public collections, including the Corcoran Gallery of Art in Washington, D.C., the Portland (Maine) Museum of Art and the National Museum in Udine, Italy. Gussow wrote *A Sense of Place: The Artist and the American Land*, and later curated a two-museum exhibition based on the book. As an art activist, he created and then co-directed the International Shadow Project, commemorating the bombing of Hiroshima.

Walter Hatke's paintings are serene evocations of light-filled spaces, both indoors and out. He earned advanced degrees from the University of Iowa, once served as a sculptor's assistant to Alexander Calder, and for the last five years has been a professor of art at Union College in Schenectady, New York. Hatke's work is included in the collections of the Art Institute of Chicago, and the Metropolitan Museum of Art in New York, among many others. A long-time exhibitor with Robert Schoelkopf Gallery, he is now represented by Babcock Galleries in New York.

Benito Huerta of Texas is formulating a cross-cultural pictorial language, combining elements of Latino imagery with profoundly original and timely motifs which spring from materials at hand. Born in Corpus Christi forty-one years ago, Huerta has rapidly established himself as one of the most provocative painters from the Southwest. He has degrees from New Mexico State University and the University of Houston. In 1990, the Contemporary Arts Museum in Houston organized a major show of Huerta's work under the title "Attempted, Not Known," which was widely circulated. His work is in the Menil Collection and the Museum of Fine Arts, both in Houston.

Keith Jacobshagen ardently celebrates the great natural beauty he finds in Nebraska. A painter of sweeping skies and eye-inviting back roads, Jacobshagen was born in Kansas, and earned degrees at the University of Kansas and the Kansas City Art Institute. Among his solo shows have been exhibits at the Sheldon Memorial Art Gallery in Lincoln, Nebraska and the Museum of Fine Arts at Utah State University. Jacobshagen has paintings in a number of public collections including the Joslyn Art Museum in Omaha, Norton Simon Museum in Pasadena and the Nelson-Atkins Museum of Art in Kansas City. He is a professor of art at the University of Nebraska in Lincoln. Jacobshagen is represented by Babcock Galleries in New York.

Elena Jahn's energy-filled art works reflect her deep immersion in the landscapes of two islands, Monhegan in Maine and Puerto Rico. A Fulbright winner to Paris, she received degrees from both Syracuse and Wisconsin universities. Jahn has has sixteen solo shows including a 1991 exhibit at the Portland (Maine) Museum of Art. She is represented by Frost Gully and O'Farrell galleries in Maine and the Fenn Gallery in Puerto Rico.

For almost thirty years **G. Peter Jemison** has pursued dual goals, to exhibit his varied artworks and to advance the cause of Native-American art. A member of the Seneca Nation, forty-eight year old Jemison is currently directing the museum on the reservation at Victor, New York. His work has been shown in all parts of the U.S. and was discussed in Lucy Lippard's recent book, *Mixed Blessings: New Art in a Multicultural America*. In 1987, Jemison has a mid-career retrospective at the Museum of the Plains Indian in Montana.

Mary Koneff's light-suffused paintings have a timeless air. A graduate of Antioch College in Ohio, Koneff has exhibited in a quartet of solo and two-person shows in California, as well as a large number of group exhibitions in Los Angeles and San Francisco.

There is a robust, muscular quality to **Michael Ambrose Lathrop**'s high energy landscape paintings. Thirty-five year old Lathrop was born in Greenfield, Massachusetts and took degrees in painting from both Syracuse and Corpus Christi State University. He is now a professor at the latter institution. Lathrop has a special affection for the south Texas terrain which serves him well as subject matter. Three galleries represent him: Carrington-Gallagher in San Antonio, Arnold Gottlieb in Toronto, and Barbara Gillman in Miami.

Well into his eighties, **Eugene "Bud" Leake** shows no sign of diminished energy. A distinguished and prolific artist, Leake served as President of the Maryland Institute, College of Art in Baltimore for more than twelve years. His formal training and education was at the Yale School of Art and Architecture. Leake's good sense and sound advice has led to service on the boards of the New York Studio School, the MacDowell Colony, and the Guggenheim Foundation, among many others. His paintings are in the permanent collections of the Corcoran Gallery of Art in Washington, D.C., the Owensboro Museum in Kentucky and the Baltimore Museum of Art, to name a few. Leake is represented by C. Grimaldis Gallery in Baltimore.

Earl W. Lehman's deep immersion in the local landscape is reflected in both his artwork and his organic life style. A BFA graduate of Kutztown (Pennsylvania) University, Lehman has exhibited in every corner of Pennsylvania, and was featured in a recent Director's Choice show at the Sardoni Gallery in Wilkes-Barre.

Joel Corcos Levy has the advantage (or burden) of springing from a family in which his father and his mother were professional artists. Absolutely committed to *plein air* painting, Levy brings a robust brush and quick eye to his jaunty landscapes. Educated at Philadelphia College of Art, Pratt Institute Institute, and the Arts Student League, Levy at one time directed the pioneering Artists for Environment program in the Delaware Water Gap National Recreation Area. One of his paintings was included in a recent American Academy and Institute of Arts and Letters Annual Purchase exhibition. Since 1988, Levy has been represented by Babcock Galleries in New York.

Peter M. Loftus and California light go together. A realist with a painterly touch, Loftus teaches art at Cabrillo College in Aptos, California. He has had sixteen solo shows on both coasts, including six exhibitions at Fischbach Gallery in New York. Loftus has paintings in the permanent collections of the San Jose Museum of Art and the Hunter Museum in Chattanooga, as well as a long list of major corporate and banking collections.

Sheridan Lord's paintings have a remarkable presence. A painter's painter, Lord has tended to work outside of the mainstream art and exhibition community, finding ready purchasers of practically every painting he completes. His collectors are drawn from a veritable who's who of the film, literary and museum worlds. Lord once taught at the now defunct Brooklyn Museum Art School.

A one time Artist-in-Residence in the Utah National Parks (supported by a joint NEA-America the Beautiful Fund grant), **Joe Miller** is a painter whose abstract images spring from intense, personal encounters with the physical landscape. A graduate of Utah and Wisconsin universities, Miller was featured in the film *A Sense of Place: The Artist and the American Land*, produced by Nebraska ETV. His most recent solo and two-person shows have been in the Pacific northwest, including the Chetwynd Stapylton Gallery in Portland, Oregon.

Judy Molyneux's paintings are prompted by deep attachments to the romantic, deeply moving landscape around Bolinas, California. Although her painting reproduced in this book depicts a "downtown" vignette, Molyneux more typically produces paintings with sweeping panoramas and, more recently, intense, abstract, swirling responses to the life which surrounds her. She was raised in Allegheny County, Pennsylvania, and earned degrees from the University of Michigan. It is clear, however, that the brooding spaces and the towering eucalyptus groves are where she feel most at home.

Fifty-seven year old **Ben Frank Moss** has been around. A graduate of both Boston University and Dartmouth College, he returned to Dartmouth where he now serves as Professor and Chair of the Studio Art Department. His paintings have been

shown in all parts of the nation, including the Kraushaar Gallery in New York, which continues to represent him, along with the Susan Conway Carroll Gallery in Washington D.C., and Gallery Sixty-Eight in Belfast, Maine. Moss has been an artist-in-residence in Melbourne, Australia, at the MacDowell Colony in New Hampshire, and at Yaddo in Saratoga Springs, New York.

Kazuko Nagao produces paintings which make people smile. She earned an undergraduate degree from Kyoto Gakugei University and an MFA from City College of New York. Since 1987, Nagao has shown in twenty-five group exhibitions, mostly in the New York metropolitan area. Her solo shows include venues at the Bodley Gallery in New York, the Bergen Museum of Art and Science in Paramus, New Jersey, and the Hampton Square Gallery in Westhampton on Long Island.

Dan Namingha manages to produce strikingly beautiful paintings which at once are thoroughly contemporary and totally responsive to ancient traditions. Born in the Tewa village of Polacca, Arizona on the first mesa, Namingha grew up speaking both Tewa and Hopi. At the age of fifteen, he was given a scholarship to the University of Kansas, and later studied at the Institute of American Indian Art in Santa Fe and the American Academy of Art in Chicago. He has had solo shows throughout the nation and will be given an exhibition at Peabody-Fogg Museum in Cambridge, Massachusetts in 1994. The USIA circulated a show of Namingha paintings across the eastern European block. His work is included in the British Royal Collection, London, the Dahlem Museum in Berlin, and the Heard Museum, Phoenix. Namingha recently presented a lecture at the Maori Contemporary Museum in New Zealand.

The less one knows about **Emily Nelligan**, the happier she is likely to be. Showing remarkable restraint, Nelligan has limited herself to making charcoal drawings. Responding to her work, noted art historian Meyer Schapiro once wrote, "Emily Nelligan's drawings are beautiful poems in blacks of a rare delicacy of tone and surface—absorbing visions of landscapes she has meditated in stillness and solitude." In 1982, her Maine works were the subject of a book published by Tidal Press, aptly titled *Maine Drawings*. Her work was included in "The Maine Muse" at the Paesaggio Gallery in Hartford in 1992. Nelligan and her etcher husband, Marvin Bileck, were featured in a recent two-person show at the Queens College Art Center, Flushing, New York.

Tom Nelson claims to paint the environment, not nature. His modest-scaled paintings depict pieces of the world often neglected by landscape painters. Nelson holds a degree from the State University of New York at New Paltz and has taken additional study at SUNY/Albany. He has had five solo exhibitions in his home region. Nelson also served as curator for several exhibitions including "The Realism Show" at the TED Gallery in Albany and "The New Response: Contemporary Painters of the Hudson River," for the Albany Institute of History and Art. He is also a celebrated kayak builder.

Peter Nye continues to reinvigorate the realist tradition in painting. He studied art in London and at the Yale Summer School, taking a degree in both art and literature at the University of California/Santa Barbara. In addition to easel painting, Nye completed two dioramas for the California Academy of Sciences in Golden Gate Park, San Francisco. Thirty-nine year old Nye is represented by Contemporary Realist Gallery in San Francisco. A painting of his was recently acquired by the Oakland Museum.

Joseph Oddo brings a sharp eye and an understated palette to his figurative paintings. He holds degrees from the University of Richmond in Virginia, the School of Visual Design at Illinois Institute of Technology and the San Francisco Art Institute. Oddo has taught at the Institute and also at Stanford and the University of California at Davis. His group shows include museums and galleries in Denmark and Sweden as well as several in California.

Joanna Osburn-Bigfeather says her work, "is about trying to re-establish native peoples' history in the North American landscape, to rewrite our history in a visual sense." Her grandmother was a full-blooded Cherokee. Osburn-Bigfeather has earned degrees from the State University of New York at Albany, the University of California at Santa Cruz, and the Institute of American Indian Arts in Santa Fe. Her works are in the Smithsonian, the Heard Museum in Phoenix and the Brooklyn Museum. In recent years, Osburn-Bigfeather finds herself riding the crest of enormous interest in contemporary Native American art. Since 1985, she has been invited to show her works in an incredible forty-two exhibitions.

Marjorie Portnow often compresses a lot of observation into a small space. She has had fourteen solo shows, including several at New York galleries. Portnow studied at Pratt, Skowhegan and the Art Students' League and earned degrees from Western Reserve in Cleveland and Brooklyn College. In recent years she has been a professor of studio art at the University of California at Santa Cruz. Her impressive list of group shows includes "The New Response: Contemporary Painters of the Hudson River," organized by the Albany Institute of History and Art, and a recent purchase awards show at the American Academy and Institute of Arts and Letters.

Don Powers works out of a long realist tradition. Born in Tennessee forty-three years ago, he has paintings in the permanent collections of such diverse public institutions as the Georgia Museum of Art in Athens, the Hunter Museum in Chattanooga, the Museum of Modern Art in Haifa, Israel, and the Butler Institute of American Art in Youngstown, Ohio. In New York, Powers has shown with the Kennedy Galleries and the Sherry French Gallery.

To see a city with fresh eyes, go with **Catherine Redmond**. Her special feeling for landscape has been demonstrated in solo shows in Ohio, Vermont and at the Blue Mountain Gallery in New York. A graduate of Harpur College, SUNY in Binghamton, New York, Redmond also studied at the Art Students' League, where she is now an instructor in drawing and painting. For a number of years, she lived in Ohio, teaching at the Cleveland Institute of Art. In addition to inclusion in the Butler Institute, her paintings are in numerous corporate collections. A recent article succinctly described her works as "A case of less being better."

Celia B. Reisman finds poetic inspiration in older suburbs. She earned degrees from Carnegie-Mellon University in Pittsburgh and from Yale. Reisman has been given eleven solo shows including an exhibition at the Hood Museum at Dartmouth. She has taught at a number of colleges, among them Temple, Dartmouth, Swarthmore, Goucher, and Amherst. Reisman is represented by two galleries, Gross McLeaf in Philadelphia and Jan Cicero in Chicago.

Paul Resika's feet may sometime seem to be planted in the 19th century; his head, eyes, and hands are clearly of this time and place. One of the nation's most celebrated figurative artists, Resika has shown remarkable staying power, showing his work year after year in some of the most prestigious galleries, including the Peridot, Washburn, Graham Modern and Salander-O'Reilly, his current representative. Resika's paintings are included in the collections of the Metropolitan Museum of Art, New York; National Museum of American Art, Washington, D.C.; and the Parrish Art Museum on Long Island, among many others. In 1977 he received an Academy Institute Award in Art from the American Academy and Institute of Arts and Letters. Resika had a Guggenheim Fellowship in 1986.

Edward Rice lives where he was born forty years ago, in North Augusta, South Carolina. His paintings have been included in a large number of group exhibitions throughout the Carolinas, Georgia, and Florida. Rice has paintings in several public collections, including the Gibbes Museum of Art in Charleston, South Carolina and the Morris Museum of Art in Augusta. A recent essay about Rice by Jeffrey Day was headlined, "Resurrecting the Mundane." In 1988, he had an NEA Regional Fellowship.

Dana Roberts' quiet paintings are getting a little less quiet these days. A graduate of the University of California at Santa Cruz, she has had several solo exhibitions in the Pacific northwest, mostly at the Quartersaw Gallery in Portland, Oregon, her current representative. Dana was born in Georgia forty-two years ago and now lives with her painter husband, Joe Miller, on San Juan Island, Washington.

Vincent D. Smith has had a long and varied career, responding as an artist to jazz, the urban environment, and to the African landscape and traditions. His work is included in the collections of the Museum of Modern Art in New York, the National Museum of American Art in Washington, D.C., the National Museum of Afro-American Artists in Boston, and the Schomberg Library for Black Culture in New York, among many others. Smith illustrated an Amiri Baraka book and has completed several mural commissions in the New York area. Smith is represented by G. W. Einstein Company in Soho. A Baraka article in *The Black Nation* described Smith as "The Original Hipster as Artist."

Marie Thibeault's paintings are arenas of action, in which natural elements struggle with paint to arrive at what appears to be a temporary equilibrium. She holds degrees from Rhode Island School of Design, San Francisco State University, and the University of California at Berkeley. Since 1975, Thibeault paintings have been included in over fifty group shows, with most coming in the last few years. Her teaching includes Humboldt State University in Arcata, California, the San Francisco Art Institute, and currently, California State University at Long Beach. A 1990 review of her work was headed, "It's Not Always Pretty."

David F. Utiger lives in Peru, Vermont, a town which even many Vermonters cannot locate. His magical landscapes are the product of a solitary life. He attended a number of professional art schools and earned a degree from Washington University in St. Louis. His modest record of exhibitions has been focussed largely in Vermont and New England, denying a wider audience an opportunity to discover the intriguing qualities of his painting.

Sharon Yates is a constant seeker after form, restless in her search, often discontent with her own achievement. A long-time instructor at the Maryland Institute, College of Art, she has won an unusual number of grants and fellowships, including the Prix de Rome to the American Academy in Rome. In recent years she has built a studio in northernmost Maine, teaching summers at Sunbury Shores Arts and Nature Center in New Brunswick, Canada. Yates was the youngest painter to be included in the book, *A Sense of Place: The Artist and the American Land*.

Doug Young's constant conflict comes when art calls and the surf is up. A native of Hawaii, Young has shown great sensitivity not only to the natural beauty of the islands, but to the cultural patterns of other natives. Young attended New York University and the University of Hawaii, gaining a degree from Coe College in Cedar Rapids, Iowa. He has made a speciality of the watercolor medium and has been honored with solo exhibitions at the Contemporary Museum and the Honolulu Museum of Arts in Hawaii. Both museums have acquired Young pieces for their permanent collections. Young's exhibiting has not been limited to Hawaii, however, as he has shown in California, Washington, Missouri, and Iowa.